SFMOMA
PAINTING
AND
SCULPTURE
HIGHLIGHTS

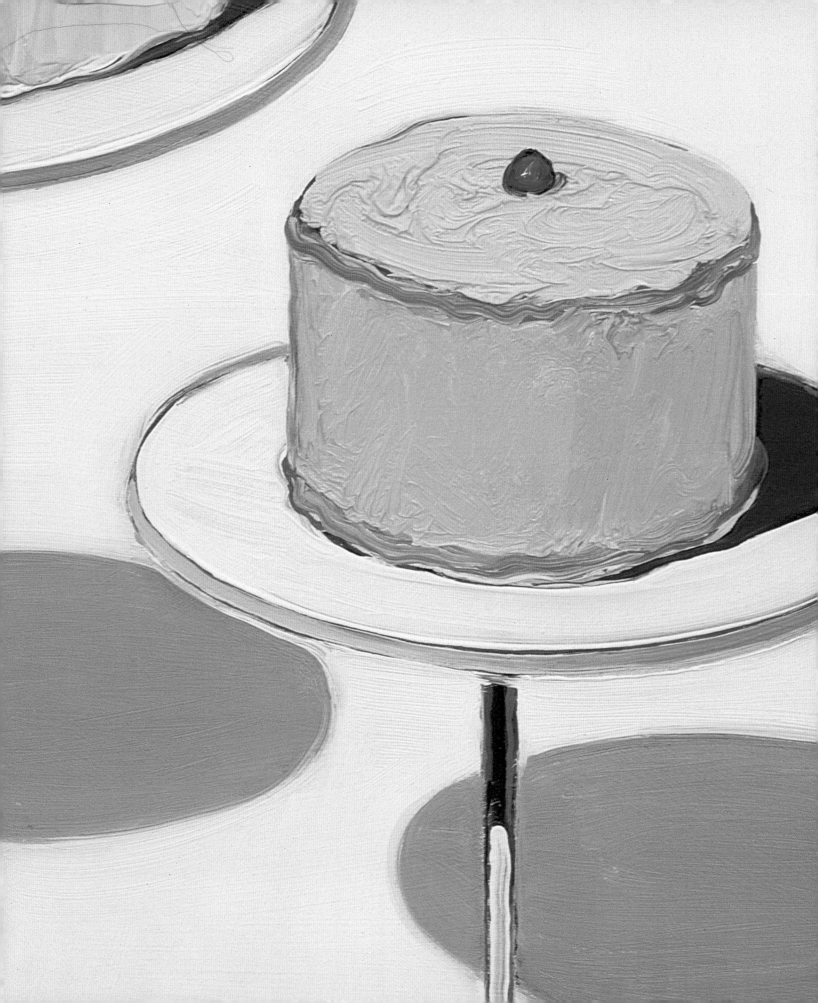

SFMOMA
PAINTING
AND
SCULPTURE
HIGHLIGHTS

Edited by Chad Coerver
Introduction by Madeleine Grynsztejn

SAN
FRANCISCO
MUSEUM
OF
MODERN
ART

Director of Publications and Graphic Design: Kara Kirk
Managing Editor: Chad Coerver
Graphic Design Manager: Keiko Hayashi
Designer: Terril Neely
Editor: Michelle Piranio
Publications Coordinator: Alexandra Chappell
Publications Assistant: Jason Goldman

Library of Congress Cataloging-in-Publication Data:

San Francisco Museum of Modern Art.
 SFMOMA painting and sculpture highlights.
 p. cm.
 ISBN 0-918471-68-0
 1. Art—Carlifornia—San Francisco—Catalogs.
 2. San Francisco Museum of Modern Art—Catalogs.
 I. Title.
 N740.5 .A68 2002
 709'.04'07479461—dc21

 2002006540

Printed and bound in Italy by Mondadori Printing.

Front cover:
RENÉ MAGRITTE
Les Valeurs personnelles
(Personal Values)
1952
oil on canvas
31 1/2 x 39 3/8 in. (80 x 100 cm)
Purchased through a gift of Phyllis Wattis, 98.562
© 2002 C. Herscovici, Brussels/Artist Rights Society (ARS), New York

Back cover:
SARAH SZE
Things Fall Apart (detail)
2001
mixed-media installation with vehicle
variable dimensions
Accessions Committee Fund purchase, 2001.0067.A–E

Frontispiece:
WAYNE THIEBAUD
Display Cakes (detail)
1963
oil on canvas
28 x 38 in. (71.2 x 96.6 cm)
Mrs. Manfred Bransten Special Fund purchase, 73.52
© Wayne Thiebaud/Licensed by VAGA, New York

CONTENTS

Left: View of the San Francisco Museum of Art's fifth-anniversary exhibition, *Contemporary Art: Paintings, Watercolors, and Sculpture Owned in the San Francisco Bay Region* (1940), which took place at the Museum's former home in the War Memorial Veterans Building.

Right: View of the painting and sculpture galleries in the San Francisco Museum of Modern Art's current building in the South of Market district.

The permanent collection is the soul of the Museum—the primary vehicle for telling the many narratives that constitute modern and contemporary art, and the key source for the Museum's curatorial and programmatic endeavors. This publication provides an overview of the ever-evolving painting and sculpture collection, which currently comprises more than 6,500 objects and focuses (within a predominantly Euro-American framework) on the important artists who have, since the beginning of the twentieth century, defined art internationally. With this volume, SFMOMA celebrates the aesthetic and intellectual achievements of those artists, acknowledges the institution's unique history and character, salutes the generosity of our patron community, and provides an informative introduction for the reader's and visitor's enjoyment and understanding.

Founded in 1935, the San Francisco Museum of Art (as it was known until 1975) was the first institution on the West Coast to commit itself to the exhibition and interpretation of contemporary art and to the examination of its historical sources. From the outset, experimental and often controversial works of art were welcomed into the collection, and many of these have since gained iconic status. To begin this book with Henri Matisse's *Femme au chapeau* (1905) is to announce SFMOMA's commitment to revolutionary developments throughout the history of Modernism. This focus on innovation has given rise over the years to a historically significant collection containing numerous masterpieces. At the same time, SFMOMA's fundamental dedication to the art of the present remains steadfast as the Museum continues to embrace iconoclastic images and ideas in its acquisition of works by younger and less-established artists.

The permanent collection has been shaped by numerous individuals—directors and curators, patrons and artists—of distinctive vision, taste, and evaluative judgment. The Museum owes much of its diverse and distinguished character to these passionate and well-informed contributors, whose efforts have helped to assemble a collection closely in tune with the best of twentieth- and twenty-first-century art.

In building the collection, the director and curators apply their passion, knowledge, and discernment when opportunities (some planned for, some unexpected) arise for the procurement of available work. With the support of the Museum's Accessions Committee, acquisitions progress simultaneously on two parallel tracks—retrospectively, and in forward motion. Attuned to a continual assessment and reassessment of the art-historical canon, including the reconsideration of previously underappreciated schools and artworks, curators work to glean key pieces from the recent past that fill in crucial gaps and strengthen areas of the collection. Concurrently, curators are dedicated to securing those works that best reflect the current peaks of visual art expression; in the process, they lay the groundwork for future masterpieces. And while the arena of contemporary-art acquisitions seems to pose the greatest "risk," it also potentially offers the greatest reward, for here the Museum may catalyze (as opposed to reflect or document) art history.

Acquisitions have long been linked to the Museum's exhibition program, as curators capitalize on the deep knowledge of and access to an artist's work that is accrued in the process of organizing a show. Important works by Arshile Gorky and Jackson Pollock were obtained from these artists' first one-person museum exhibitions, organized by the San Francisco Museum of Art in the early 1940s. Philip Guston's pivotal retrospective in 1980 spurred a generous bequest of four major paintings from the artist himself that today forms the nucleus of one of the Museum's key artist-concentrations. More recently, a number of important works by Sol LeWitt were acquired in the wake of the groundbreaking retrospective exhibition organized by SFMOMA in 2000, turning the Museum into a primary center for Conceptual and Minimal art.

It is incumbent upon each generation to reevaluate the relative importance of any artwork in the collection; thus each successive leadership furthers and also revises the predecessor's legacy. In this way a cumulative identity for the Museum is forged, an identity that is singular precisely because of the patterns of representation that arise from a succession of discerning professionals who take seriously their stewardship of a public trust. Over the course of sixty-seven years, SFMOMA has benefited from the productive tenures of six directors and affiliated curatorial staff, and with each directorship, the permanent collection has been reconsidered and opened up to new directions, resulting in continuous evolution and refinement.

It is worth noting certain aspects of the collection that make it a standout among public holdings worldwide. True masterpieces are rare in any museum, but SFMOMA is fortunate to have a number that stake out a chronological history and allow the collection to focus on certain formal, conceptual, and thematic points. Certified landmarks such as Mattise's *Femme au chapeau* beget aesthetic threads followed through to the present in works by artists such as Richard Diebenkorn and Ellsworth Kelly. With Marcel Duchamp's *Fountain* (1917/1964)—one of the twentieth century's most controversial works of art—the Museum is able to trace the lineage of Conceptual art from its inception to the work of Robert Rauschenberg, Gordon Matta-Clark, and other artists who have elaborated on Duchamp's exploration of the boundary between art and life, an overriding theme throughout the century. In addition to these acknowledged treasures, key purchases whose entries have immediately clarified and retooled the collection as a whole include Mark Rothko's *No. 14, 1960,* Andy Warhol's *National Velvet* (1963), Anselm Kiefer's *Osiris und Isis* (1985–87), and Jeff Koons's *Michael Jackson and Bubbles* (1988), to mention but a few.

SFMOMA's collection also boasts several areas of authoritative concentration. Surrealism and its contemporary directions are grounded in René Magritte's *Les Valeurs personnelles* (1952) and brought up to the present in works by Robert Gober, among others. Such themes and tendencies transcending movements and periods are constantly expanded as new acquisitions enter the collection. Importantly, since its founding, the

Museum has focused with great pride on the art of its own region, anchored by in-depth holdings of works by Diebenkorn, Wayne Thiebaud, and Richard Arneson. Special note should also be made of Clyfford Still's stunning gift in 1975 of twenty-eight monumental canvases spanning his career. The Museum's concentration of Bay Area art sets it apart from other major institutions, and gives SFMOMA a crucial grounding in its immediate community. Additional areas of focus, such as postwar German art, Central and Latin American Art, and post-Minimalism, are continually enhanced with ongoing acquisitions. Finally, SFMOMA's collection evinces monographic depth in the holdings of at least nine "core" artists: Klee, Guston, Diebenkorn, Still, Rauschenberg, Kelly, Stella, LeWitt, and Ryman. These groupings allow the Museum to trace an artist's full development, and they assist the visitor in achieving a greater understanding of the creative process.

SFMOMA's move in 1995 to a new building containing spacious galleries galvanized the Museum's staff and trustees in the pursuit of important acquisitions that would match the prominence of the Museum's new architecture. Collection-building became an institutional priority, and the striking growth, in both quality and quantity, achieved by the collection in recent years continues to this day thanks to an active and generous patron base. Indeed, SFMOMA's holdings reflect the accomplishment of generations of San Franciscans who took up the challenge to build a great collection of art in this city; this publication is a testament to their civic commitment and munificence. Visible in every gallery of SFMOMA are gifts of much-loved and significant artworks made available to the public by private individuals; such donations have had a profound and happy effect on the collection. It must suffice to cite but a few of SFMOMA's patrons here, recognizing that this can only hint at the Museum's indebtedness to a broad and vital community of donors.

From its inception, SFMOMA benefited from the philanthropy of Albert Bender, who, between the Museum's opening in 1935 and his death in 1941, donated more than 1,100 works to the collection, including a particularly significant body of Mexican Modernist paintings that forms the root of SFMOMA's commanding assembly of Latin and Central American art. Elise Stern Haas's lifelong patronage culminated in 1990 with the extraordinary bequest of some thirty works by many of the leading artists of the modern era, including Matisse. In 1984 Dr. Carl Djerassi initiated a promised and ever-growing gift of artworks by Paul Klee, providing the Museum with an especially strong concentration of this early Modernist's artistic production.

Bay Area residents Harry W. and Mary Margaret Anderson gave the Museum a powerful foundation in American postwar art with their 1972 gift of treasured works by Jasper Johns and Robert Rauschenberg, followed in 1992 with an additional donation of signature Pop art images by Roy Lichtenstein, Andy Warhol, and their contemporaries. The Andersons' generosity continues, to the Museum's delight, with the recent gift of a suite of works by Frank Stella that encompasses the artist's entire career and forms anoth-

er important monographic holding for this institution. The Museum's ability to chart the most recent trends in international contemporary art was given an unprecedented boost in 1997 when SFMOMA received 250 works from the collection of Kent and Vicki Logan, whose broad-ranging and passionate quest for the most engaging art produced since the 1980s, combined with their continued goodwill, has made this Museum a rich repository of late-twentieth-century and twenty-first-century art production.

The benevolence of trustee Phyllis Wattis has greatly transformed SFMOMA's collection. Wattis has made it her personal mission to enable the Museum to rectify historical omissions within the collection and, in so doing, to develop the ability to paint a fuller and more accurate picture of the history of modern art. In recent years she has facilitated the purchase of a number of works by the twentieth century's leading artists: Marcel Duchamp, Eva Hesse, René Magritte, Piet Mondrian, Robert Motherwell, Barnett Newman, and Robert Smithson, among others. Moreover, Wattis enabled SFMOMA to acquire twelve seminal pieces by Robert Rauschenberg from the artist's personal collection.

The remarkable generosity of these and many other individuals reflects an outpouring of community support for building the collection. A number of patrons, who wish to remain anonymous, are to be thanked for their continued underwriting of acquisitions that stretch beyond the reach of any museum fund. By way of example, in 1999 a number of anonymous donors made possible the acquisition of twenty-two works by Ellsworth Kelly, giving the Museum an incomparable core collection. Despite intense and increasing competition for an ever-dwindling supply of exemplary artworks, generous donations continue to enrich the galleries of SFMOMA, making it a premier destination for viewing modern and contemporary artworks.

SFMOMA's spectacular growth at every level has been nurtured by a lively public interest in art and culture. This illustrated handbook is an expression of the Museum's dedication to engaging and informing its audiences. With this guide, we hope to provide you with both an introduction to the great works of art in this collection and a point of departure for your own open-ended journey of exploration and appreciation. The Museum and its collection constitute a forum where we can interact with our visual culture, and perhaps discover something about ourselves in the process. Among the lessons learned may be the realization that art is alive and constantly changing, and that the Museum is a site where history is not merely presented, but is also debated and continually remade. It is our great pleasure to invite you to be part of this conversation.

Madeleine Grynsztejn
Elise S. Haas Senior Curator of Painting and Sculpture

PLATES with texts by

Janet Bishop

Julia Bryan-Wilson

Madeleine Grynsztejn

Molly Hutton

Clara Kim

Tara McDowell

John S. Weber

HENRI MATISSE

Femme au chapeau

(Woman with the Hat)

Femme au chapeau (1905) radiates with the dynamism of early Modernism. Rife with pictorial tensions and infused with layers of interpretation, Henri Matisse's portrait of his wife, Amélie, continues to engage viewers with the directness of the subject's gaze. *Femme au chapeau* was one of the "radical" paintings that ignited controversy at the 1905 presentation of the Salon d'Automne, Paris's annual contemporary art exhibition. Perhaps sensing the impending public uproar, the Salon's president had advised Matisse not to show the canvas because it was "excessively modern," the very quality that makes the picture compelling a century after its execution.

The paintings that so shocked visitors to the Salon d'Automne were soon grouped under the mantle of Fauvism, a movement christened by art critic Louis Vauxcelles when he announced upon viewing the works that he was surrounded by "fauves," or wild beasts. The pictorial strategies affiliated with Fauvism, including the use of color for expressive rather than naturalistic purposes, are clearly evident in *Femme au chapeau*. Matisse uses unexpected, even startling, colors to compose his figure: an unabashed green line sweeps across Amélie's forehead, perhaps indicating the shadow cast by her elaborate hat, and a dab of yellow on the tip of her nose suggests a ray of light hitting that contour. Besides creating effects of light, shadow, contour, and texture, these bold dabs and swatches of color also assert their autonomy as paint on a two-dimensional surface. And yet the viewer feels the need to make sense of these ambiguous forms. Perhaps fruit or flowers adorn Madame Matisse's hat, and perhaps it is a fan in mid-torque that covers her chest. Her hand might be gloved in an intricate fabric, but what are we to make of the green vertical stroke beneath it or the perpendicular orange and red horizontal band? Her face is the eye of the storm, calmly demanding our attention; yet what is her expression, and at whom or what is her gaze directed?

Matisse never intended to present a conventional portrait to the Salon d'Automne. As he explained, "I cannot copy nature in a servile way; I am forced to interpret nature and submit it to the spirit of the picture."[1] This statement elucidates Matisse's response when queried about the fantastic color of the actual dress Madame Matisse wore when posing for the portrait: "Black, of course." Matisse aimed to harness the expressive nature of color in order to convey the essence of a subject, and perhaps in this portrait of his wife he has created the most powerful embodiment of that idea in his œuvre. —TM

1. Matisse, quoted in Roger Benjamin, Matisse's *"Notes of a Painter": Criticism, Theory, and Context, 1891–1908* (Ann Arbor, Mich.: UMI Research Press, 1987), p. 195.

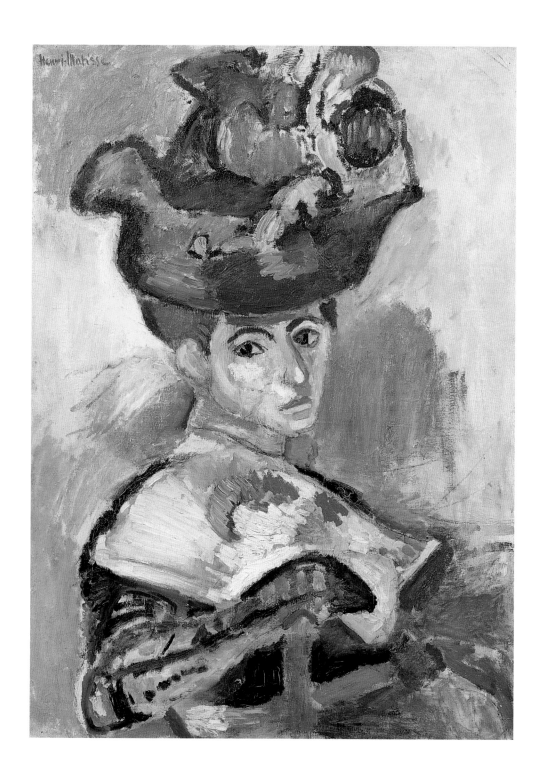

HENRI MATISSE
French, 1869–1954

Femme au chapeau
(Woman with the Hat)
1905
oil on canvas
31 3/4 x 23 1/2 in. (80.7 x 59.7 cm)

Bequest of Elise S. Haas, 91.161

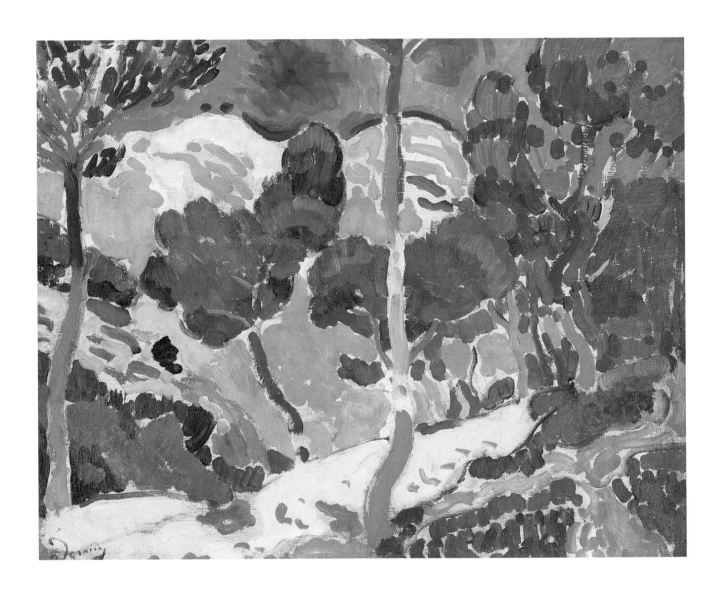

ANDRÉ DERAIN
French, 1880–1954

Landscape
1906
oil on canvas on board
19 x 24⁷⁄₈ in. (48.3 x 63.2 cm)

Bequest of Harriet Lane Levy, 50.6075

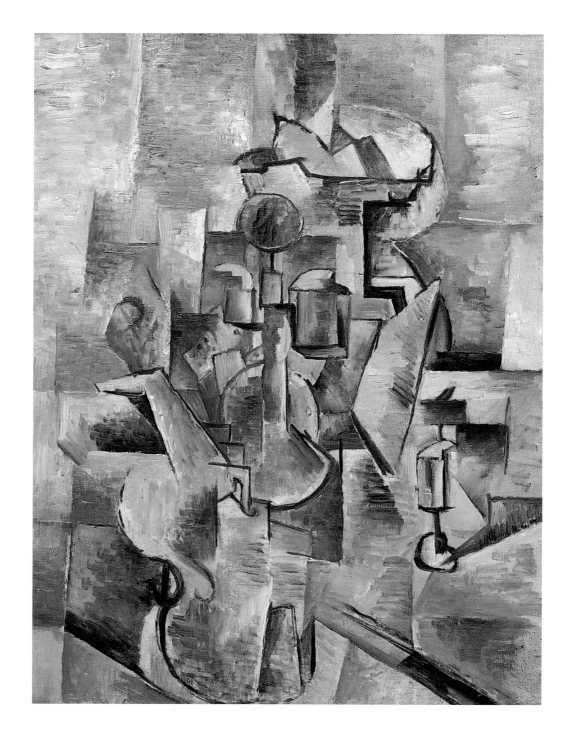

GEORGES BRAQUE
French, 1882–1963

Violon et compotier
(Violin and Fruit Dish)
[known in English as
Violin and Candlestick]
1910
oil on canvas
24 x 19 ¾ in. (61 x 50.2 cm)

Gift of Rita B. Schreiber in loving
memory of her husband, Taft
Schreiber, 89.78

FRANZ MARC
Gebirge (Mountains)

The eve of 1911 witnessed the fortuitous meeting of Franz Marc and Vasily Kandinsky. As the new year advanced, so too did the artistic kinship between the young German artist and his new Russian friend and mentor, an alliance that resulted in the founding of a new splinter group of German Expressionism, *Der Blaue Reiter* (The Blue Rider). Referencing in its name the two painters' well-established interests in both color and the subject of the horse, *Der Blaue Reiter* was not a movement or a school per se, but rather a shifting group of artists with a shared concern for spiritual harmony within the natural world.

The first exhibition staged by *Der Blaue Reiter* took place at Munich's Moderne Galerie Thannhauser in December 1911. The show consisted of paintings by an international roster of artists invited to participate by Marc and Kandinsky, including Bavaria-based painters Albert Bloch and Gabriele Münter, the composer Arnold Schönberg from Berlin, August Macke from Bonn, and Elizabeth Epstein, Henri Rousseau, and Robert Delaunay from Paris. Hanging next to a Delaunay painting of the Eiffel Tower was Marc's canvas, known then as *Landschaft* (Landscape).[1] Rare within Marc's œuvre for not featuring an animal, this work took as its subject a region of upper Bavaria that boasted the Pioneer Path, a treacherous mountain trail hiked by Marc that may have served the artist as a metaphor for the difficult journey of life.[2]

In September 1912 Marc traveled to Paris to visit Delaunay, whose experiments with luminous color and structure informed by cubist abstraction were of great interest to the German artist. Later that year, after returning to Germany, Marc painted over *Landschaft* and retitled it *Gebirge*. During this second session with the painting, he added dark lines that accentuate the prismlike nature of the icy mountains. Marc painted in a bright orange sun that peeks over the hills at the very top of the composition, recalling similar forms that were so central to Delaunay's imagery, and he activated the lower left quadrant of the painting with a virtual kaleidoscope of colors. The result is an important transitional painting that has become crucial to understanding the development of an artist whose career was cut short at the age of thirty-six by his death at the Battle of Verdun in 1916. —JB

1. See photograph by Gabriele Münter in Peter-Klaus Schuster, et al., *Delaunay und Deutschland* (Cologne: Dumont Buchverlag, 1985), p. 217, fig. 8.
2. The interpretation is Klaus Lankheit's. See Mark Rosenthal, *Franz Marc* (Munich: Prestel Verlag, 1989), p. 27.

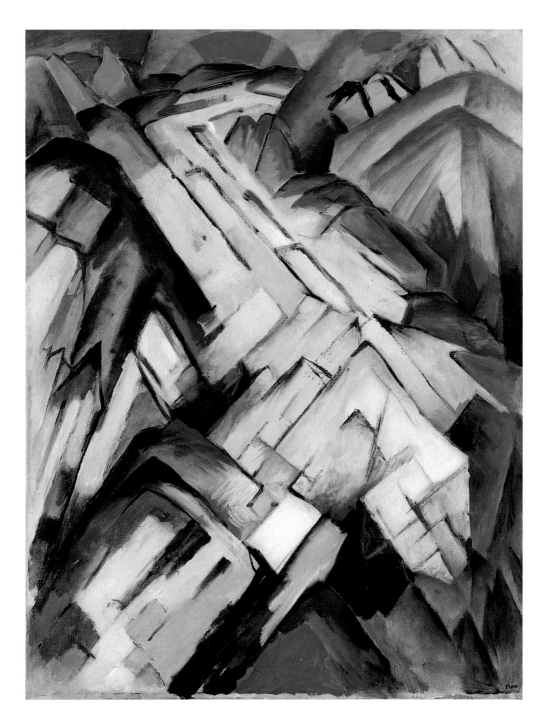

FRANZ MARC
German, 1880–1916

Gebirge (Mountains)
[formerly *Landschaft*
(Landscape)]
1911–12
oil on canvas
51 ¹/₂ x 39 ³/₄ in. (130.8 x 101 cm)

Gift of the Women's Board and
Friends of the Museum, 51.4095

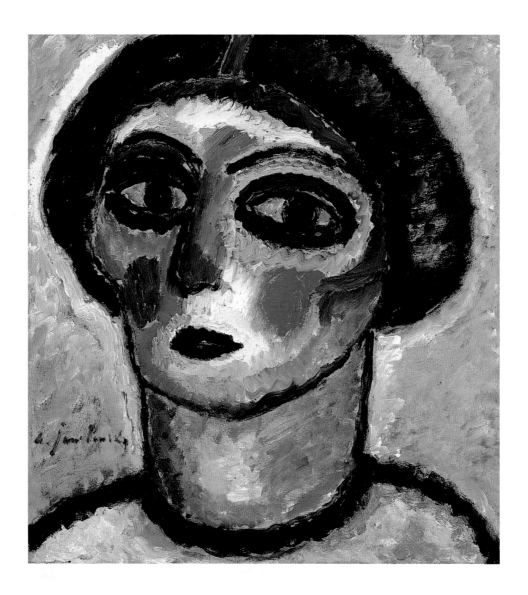

ALEXEJ JAWLENSKY
Russian, 1864–1941

Frauenkopf (Woman's Head)
1913
oil on composition board
21 ¼ x 19 ½ in. (54 x 49.5 cm)

Gift of Charlotte Mack, 50.5518

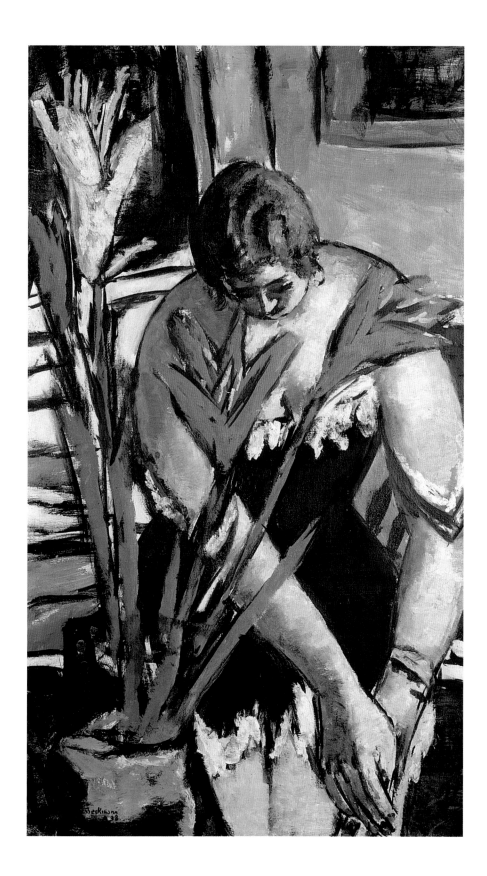

MAX BECKMANN
German, 1884–1950

Frau bei der Toilette mit roten
und weissen Lilien
(Woman at Her Toilette
with Red and White Lilies)
1938
oil on canvas
43 1/2 x 25 3/4 in. (110.5 x 65.4 cm)

MARCEL DUCHAMP
Fountain

Marcel Duchamp's *Fountain* (1917/1964) has become an icon in the history of Modern art. A prime example of Duchamp's "readymades" (works "already" made by mass production), *Fountain* was created by taking an ordinary porcelain urinal, rotating it ninety degrees from its normal position, and placing it on a pedestal. Duchamp "authenticated" the work by signing it "R. Mutt," a pseudonym derived from the plumbing manufacturer Mott Iron Works and the comic strip *Mutt and Jeff*. With this irreverent act, Duchamp single-handedly redefined what constitutes a work of art, a conceptual shift that would have profound reverberations throughout the twentieth century.

From 1913 to 1917 Duchamp created numerous readymades using such objects as a bicycle wheel, a coat hanger, a comb, and a bottle rack. By taking ordinary objects out of their usual context and presenting them as artworks, he radically changed the meaning of artistic production. Forsaking traditional formal qualities of art-making, or what Duchamp called the "retinal image," he turned instead to conceptual strategies in which the *choice* of an object was of paramount importance. In this way, he privileged the innate power of objects to conjure various meanings and associations over the creation of "original" artworks. Like the works of the Dadaists and Surrealists, with whom Duchamp is often associated, the readymades are conceptual interventions that rely on the viewer to complete the work and therefore participate in its interpretation.

When *Fountain* was anonymously submitted for the first exhibition organized in 1917 by the American Society of Independent Artists at the Grand Central Palace in New York, it was flatly rejected by the board of directors and ultimately pulled from the show just before the opening. Duchamp was a founding, and prestigious, member of this artists' organization, so his decision to make an anonymous submission underscored his commitment to the conceptual act of subverting artistic authorship. Although the work was never displayed in the exhibition, it achieved notoriety through word of mouth and through an article published in the journal *The Blind Man*.[1] Titled "The Richard Mutt Case," the article was accompanied by a photograph of *Fountain* taken by Alfred Stieglitz. This is the only record of the original work, which was often called "The Madonna of the Bathroom." There are differing historical accounts about whether the work was lost, stolen, or destroyed after its fate at the Society of Independent Artists show. What remains of *Fountain* are sanctioned replicas made by Sidney Janis in 1950, Ulf Linde in 1963, and Arturo Schwarz in 1964. —CK

1. "The Richard Mutt Case," *The Blind Man* 2 (May 1917): 2–3.

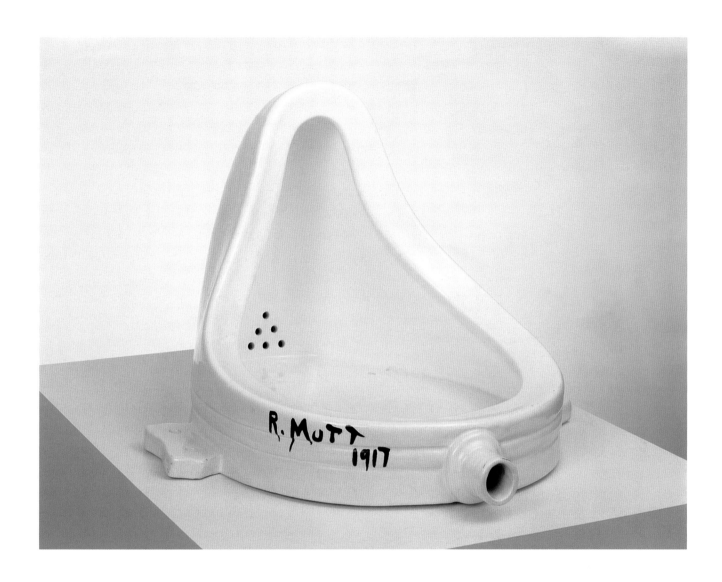

MARCEL DUCHAMP
French, 1887–1968

Fountain
1917/1964
glazed ceramic with paint
15 x 19 ¼ x 24 ⅝ in. (38.1 x 48.9 x 62.6 cm)

Purchased through a gift of Phyllis Wattis, 98.291

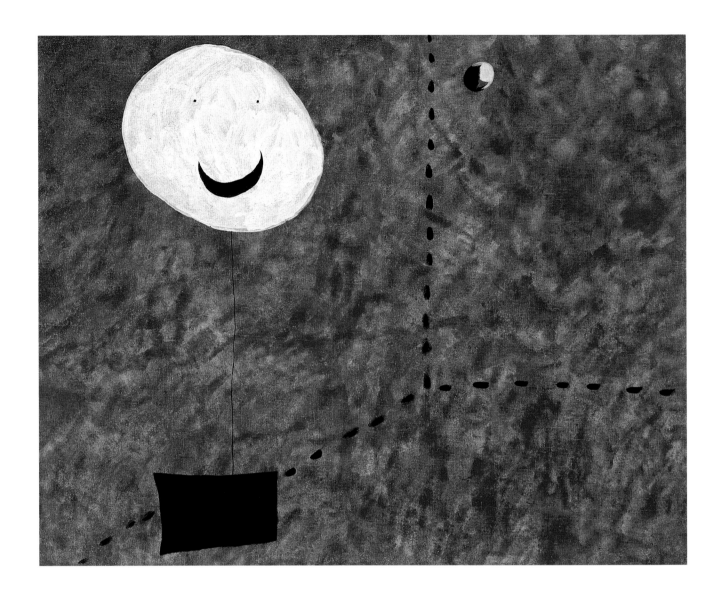

JOAN MIRÓ
Spanish, 1893–1983

Peinture (Painting)
[formerly *Dark Brown
and White Oval*]
1926
oil on canvas
28 7/8 x 36 1/4 in. (73.4 x 92.1 cm)

Gift of Joseph M. Bransten in memory
of Ellen Hart, 80.428

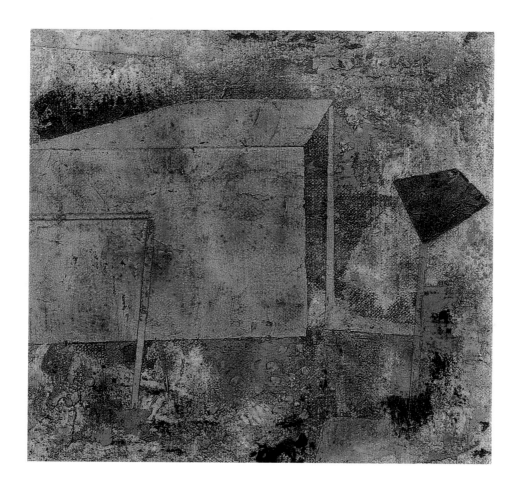

PAUL KLEE
German, born Switzerland,
1879–1940

Rotes Haus (Red House)
1929
oil on canvas mounted on cardboard
10 x 10 ⁷⁄₈ in. (25.4 x 27.6 cm)

Gift of the Djerassi Art Trust, 92.261

CONSTANTIN BRANCUSI
La Négresse blonde
(The Blonde Negress)

In his quest to make sculpture that conveyed "the essence of things,"[1] Constantin Brancusi made a decisive break with traditional Western forms of plastic art, which had remained, up to and including the work of Auguste Rodin, largely imitative of perceived reality. Brancusi studied briefly in Rodin's atelier in 1907, and acknowledged the older artist's capacity for conveying emotion. Yet despite the fact that the basis for much of Brancusi's art was the human figure, he sought forms that were more independent from visual reality. "Sculpted nude bodies are less sightly than toads," he wrote in one of the most pointed of his aphorisms, making his position on realism absolutely clear.[2]

Brancusi's sculptural vocabulary consists of relatively few highly distilled forms, one of the most significant being the ovoid, or egg shape. Charged with symbolic potential, the ovoid could allude to a completely hermetic, self-sufficient entity or, alternatively, to the human head. *La Négresse blonde* (1926) elicits both of these associations. The title of this bronze sculpture refers to a striking African woman whom Brancusi had met in Marseilles. He may also have had in mind the poem of the same title by Georges Fourest, which contains the line: "La belle Négresse, la Négresse blonde."[3] In this interpretation of the sculpture, the perfect, upturned ovoid serves as the woman's head, her distinguishing features reduced to a pair of full lips, a chignon, and a zigzag ornament at the back of the neck, perhaps denoting a scarf or the lower part of her coiffure. The sculpture's three-part pedestal, comprising a cylinder, Greek cross, and plinth (not pictured), thus functions as the subject's body, shoulders, and neck. The bronze ovoid portion of the sculpture alone, however, can be interpreted with equal facility as the complete body of a golden fish, in which the top and rear embellishments are its dorsal and tail fins.

More than the "skin" color changed when Brancusi had his 1924 marble sculpture *La Négresse blanche* (The White Negress) cast in bronze to make *La Négresse blonde*. This shift in materials might have signified reincarnation, an interpretation supported by the artist's own recounting of several occasions in his life when he had experienced spiritual rebirth. Veined and opaque in her previous existence, *La Négresse* became highly reflective, almost immaterial, through the artist's tireless polishing of her bronze form. "A work of art must be carried out like a perfect crime," Brancusi remarked, "faultless with no trace of authorship."[4] —JB

1. Brancusi, quoted in Eric Shanes, *Constantin Brancusi* (New York: Abbeville Press, 1989), p. 105.
2. This and other statements by Brancusi are printed in Carola Giedion-Welcker, *Constantin Brancusi* (New York: George Braziller, Inc., 1959), pp. 219–20.
3. See Radu Varia, *Brancusi* (New York: Rizzoli, 1986), p. 303, n. 10.
4. Brancusi, quoted in ibid., p. 40.

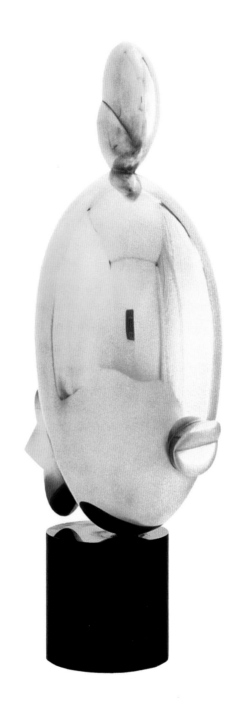

CONSTANTIN BRANCUSI
French, 1876–1957

La Négresse blonde
(The Blonde Negress)
1926
bronze, ed. 4
15 1/8 x 4 7/8 x 7 3/8 in. (38.4 x 12.4 x 18.7 cm)

Gift of Agnes E. Meyer and Elise Stern Haas, 58.4382

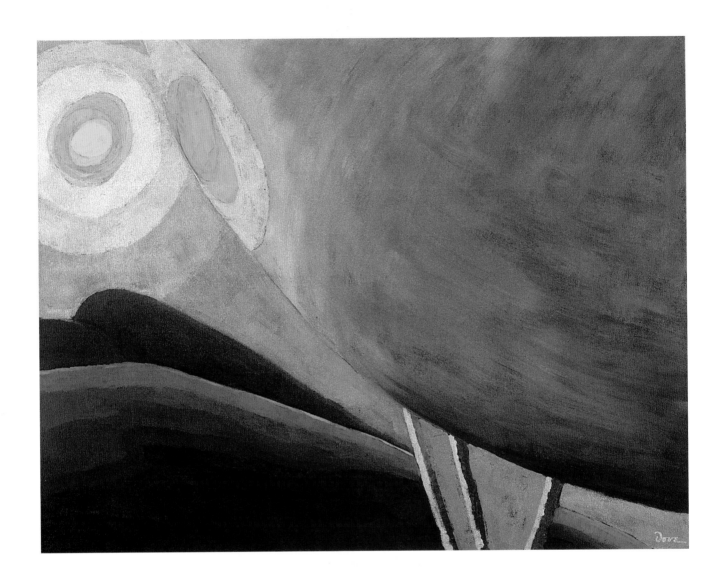

ARTHUR DOVE
American, 1880–1946

Silver Ball No. 2
1930
oil and metallic paint on canvas
23 1/4 x 30 in. (59.1 x 76.2 cm)

Rosalie M. Stern Bequest Fund purchase,
59.2348

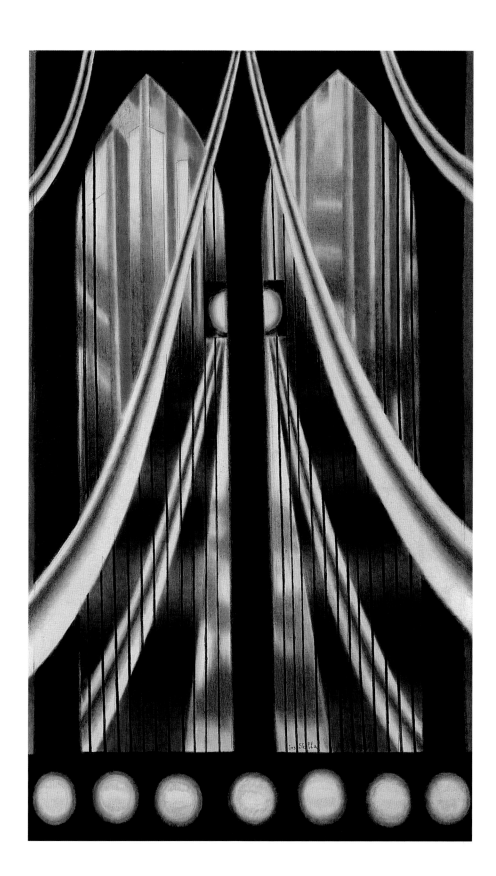

JOSEPH STELLA
American, born Italy, 1877–1946

Bridge
1936
oil on canvas
50 ⅛ x 30 ⅛ in. (127.3 x 76.5 cm)

WPA Federal Arts Project Allocation
to the San Francisco Museum
of Modern Art, 3760.43

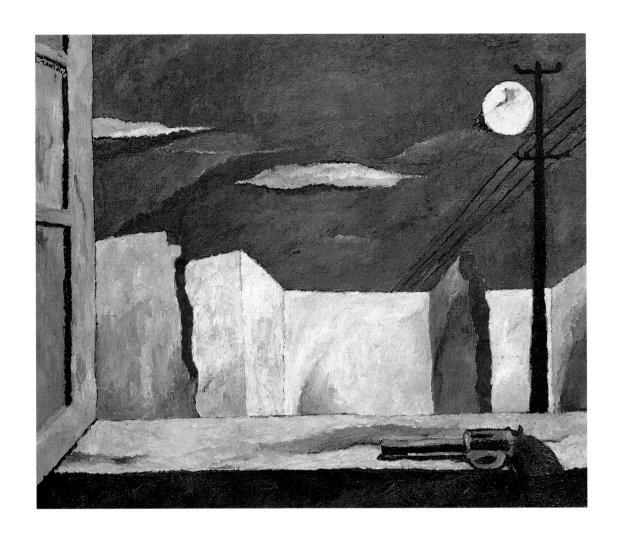

RUFINO TAMAYO
Mexican, 1899–1991

The Window
1932
oil on canvas
19 ³/₄ x 23 ⁵/₈ in. (50.2 x 60 cm)

Gift of Howard M. Putzel, 35.3399

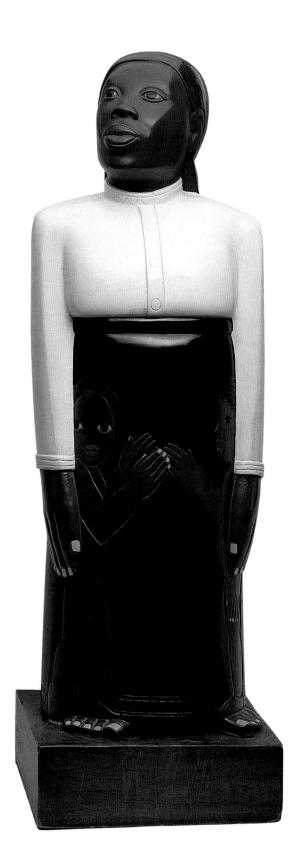

SARGENT JOHNSON
American, 1888–1967

Forever Free
1933
wood with lacquer on cloth
36 x 11 ½ x 9 ½ in.
(91.4 x 29.2 x 24.1 cm)

Gift of Mrs. E. D. Lederman, 52.4695

During an eighteen-month sojourn in San Francisco, Frida (also Frieda) Kahlo painted this portrait of herself and her new husband, Diego Rivera, for art patron and future supporter of the Museum Albert Bender. Kahlo had accompanied Rivera to the Bay Area after he received a commission to execute murals at the San Francisco Stock Exchange and the California School of Fine Arts. The banderole held in the dove's mouth above

FRIDA KAHLO
Frieda and Diego Rivera

the couple reads: "Here you see us, me Frieda Kahlo, with my beloved husband Diego Rivera. I painted these portraits in the beautiful city of San Francisco, California, for our friend Mr. Albert Bender, and it was in the month of April in the year 1931."

The seventy years spanning the creation of this painting and the present moment have witnessed immense changes in the status and role of women and, by extension, the experience of women artists. In the context of her time, Kahlo's individual, unapologetic, and gender-conscious contribution to a male-dominated Modernism is all the more remarkable. In this image, Kahlo sparingly employs traditional devices of scale, composition, and iconography to position herself as the companion of an icon of American Modernism, acclaimed Mexican muralist Diego Rivera (see overleaf). Rivera's immense mass is planted solidly on the floor of the picture plane, while Kahlo's diminutive form seems to float beside him, anchored only by his slightly proffered left hand. Her head tilts toward him, both acknowledging his presence and deferring to it, yet his head turns away from her figure. He holds the classic artistic attributes of palette and brush, and she in turn holds his hand.

Portraiture is a constant negotiation of self-representation and self-invention. In actuality, Rivera was over a foot taller than Kahlo, weighed three times as much as his wife, and was twice her age. His career was well-established when this commission occasioned their visit to San Francisco, while her career had barely begun. With these facts in mind, one wonders if this image depicts truthful self-representation or a more inventive, veiled critique of Kahlo's subordinate role in the relationship.

Kahlo's numerous self-portraits frequently associate the artist with her native culture, as her traditional Mexican attire in *Frieda and Diego Rivera* implies. She was also fascinated by the spiritual and mythological archetypes of both pre-Columbian and ancient Egyptian cultures, identifying with figures representing nature, the moon, fertility, renewal, and sorrow. Although the format of *Frieda and Diego Rivera* suggests a colonial wedding portrait, the abstracted, simple forms of the couple—the larger, more powerful male supported by a smaller, yet unflinching female—recall Egyptian statues of pharaohs and their queens. The image, then, is the beginning of Kahlo's careerlong pictorial identification with the spiritual and mythic abstract ideals of woman, mother, goddess, creator, and sufferer. —TM

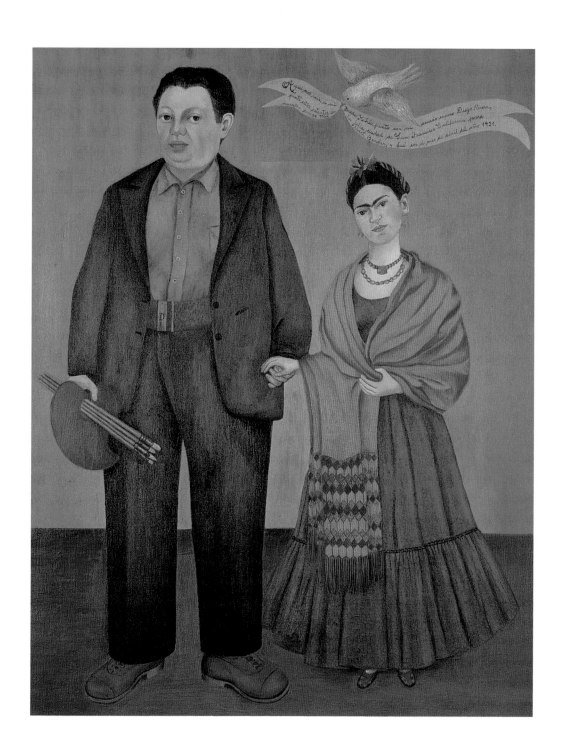

FRIDA (FRIEDA) KAHLO
Mexican, 1910–1954

Frieda and Diego Rivera
1931
oil on canvas
39 3/8 x 31 in. (100 x 78.7 cm)

DIEGO RIVERA
The Flower Carrier

Diego Rivera's *The Flower Carrier* (1935) is widely acknowledged as one of the finest works on wood panel by this great Mexican muralist. It was purchased for the new San Francisco Museum of Art by Rivera's San Francisco friend and patron Albert M. Bender in 1935, at the height of the artist's career. In a letter to the painter, Bender asked that Rivera himself select "a representation of your work at its finest and best."[1] Rivera's choice was one of his largest paintings of the mid-1930s, a rhythmical, powerful image of Mexican peasants carrying a basket of flowers. *The Flower Carrier* is painted in oil and tempera on Masonite with a white undercoat of gesso. As Bender noted, it has "something of the same feeling as [the] frescoes"[2] that had brought Rivera to the pinnacle of international renown and had earned him commissions for murals in San Francisco, Detroit, and New York. Indeed, the artist's 1931 exhibition at the Museum of Modern Art, New York, had outdrawn the Matisse exhibition of the previous year.

Rivera's career reveals a fluid assimilation of the traditions of European Renaissance painting and the most radical developments of his era. As a young artist he moved in 1907 from Guanajuato, Mexico, to Spain and continued on to Paris, where he eventually established a considerable reputation as a cubist painter. He lived in Paris until 1920, traveling briefly to Mexico in 1910 at the outset of the Mexican Revolution. On a trip to Italy in 1920–21, he was deeply impressed by the Florentine fresco cycles of Giotto and Cimabue. Returning to postrevolutionary Mexico in 1921, Rivera was commissioned by the new government to execute a series of magnificent wall paintings telling the story of the Mexican Revolution in historical and symbolic form. The resulting works melded these various influences into a style and thematic program that distinguish Rivera as one of the singular artists of his time.

The Flower Carrier is one of many images Rivera made of peasants, and in it his sympathetic respect for manual labor is apparent, echoing his Marxist political convictions. As in many of the artist's depictions of Mexican agricultural workers, the subjects here are weighted down by a heavy burden, yet painted with a sculptural solidity that lends them a monumental dignity. Both figures are shown close to the earth, as the flower carrier kneels to allow the woman to secure an immense basket of blossoms on his back. Given the highly symbolic and politically articulated nature of Rivera's œuvre, a fairly specific interpretation of *The Flower Carrier* seems justified. Clearly, the generalized features of the two *campesinos* present them as idealized representatives of their class, working together and in harmony with the natural world. Although presented virtually as beasts of burden, they labor—like Rivera himself—to bring beauty to others, as embodied by the flowers that are the focus of their work. —JSW

1. Albert Bender, letter to Diego Rivera, 29 March 1935, in the director's files of the San Francisco Museum of Modern Art.
2. Albert Bender, letter to Mrs. Walter Siple, 25 September 1935, in the director's files of the San Francisco Museum of Modern Art.

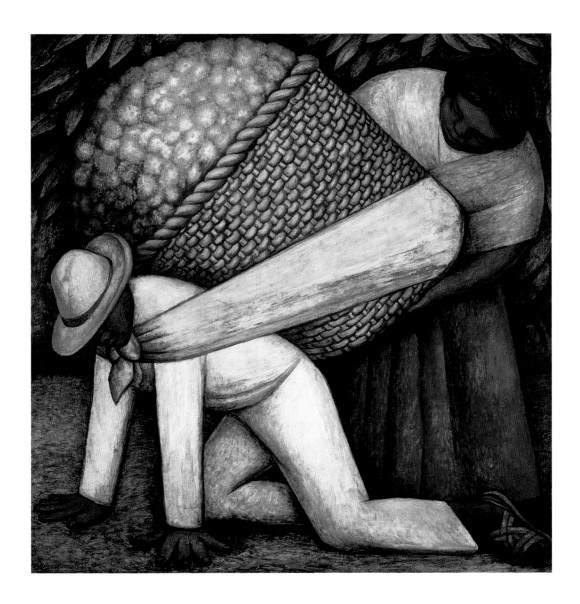

DIEGO RIVERA
Mexican, 1886–1957

The Flower Carrier
[formerly *The Flower Vendor*]
1935
oil and tempera on Masonite
48 x 47 ¾ in. (121.9 x 121.3 cm)

Albert M. Bender Collection;
Gift of Albert M. Bender in memory
of Caroline Walter, 35.4516

PIET MONDRIAN

Composition with Red, Yellow, and Blue

A founding member of the Dutch avant-garde group De Stijl, Piet Mondrian pursued one of Modernism's most strident quests for ultimate flatness and a perfect balance of pictorial elements. This mission had grander meanings for him, as he was convinced that the integration of parts into a whole would lead to a total synthesis of life and art. His search for the absolute in painting led him to a formal idiom that he termed "neo-plasticism," based upon a core principle of "dynamic equilibrium." In his voluminous writings about his aesthetic theories, Mondrian contended that the strength of a canvas derives from the harmony of oppositions—white intersecting with black, planes crossed with lines. He therefore built his compositions using several constant features, including modular perpendicular lines and primary colors set against white space.

The painting illustrated at right was first exhibited in 1936 in a form quite different from its final state. Originally titled *Composition No. III Blanc-Jaune* (Composition No. III White-Yellow), it featured yellow and white rectangular fields bound by Mondrian's trademark black lines. The work had a ladderlike structure, characteristic of his work in the mid-1930s, that emphasized the verticality of the canvas. Mondrian reworked it after moving to New York in 1940, an experience that energized him and prompted him to experiment with what were for him bold, radical choices, including the use of nonblack lines. His New York canvases exhibit a freer use of color and a denser weaving of the lines, causing what art historian Yves-Alain Bois has termed "optical flickering."[1] Mondrian returned to some of his earlier works in order to jazz them up with his newfound techniques; this painting is among them, one of only seventeen so-called "transatlantic paintings" begun in Europe but repainted extensively once he was in New York. In the final version of the work, titled *Composition with Red, Yellow, and Blue* (1935–42), Mondrian introduced the blue plane in the bottom left and added two short red lines above it.

Mondrian strove for a picture plane in which there was no precedence given to figure or ground. He painted with thick, rich whites, often carefully modulating their exact shade, and his surfaces reveal some of the most painterly brushwork in the history of art. Cut into the built-up white are shallower, glossy black lines that look almost lacquered. His pure primary colors are uninflected by neighboring tones since they are often bounded by black and set off against the white. Lines for him could never be diagonal or curved: "The straight line tells the truth," he once wrote. Mondrian believed that the path to a new experience of truth could be found within the tensions and complex relationships manifested in primary colors and right angles. As he wrote in his manifesto-like essay "The New Plastic in Painting" (1917), "The rhythm of the relationship of color and dimension (in determinate proportion and equilibrium) permits the absolute to appear within the relativity of time and space."[2] —JBW

1. Yves-Alain Bois, "Piet Mondrian, *New York City*," in *Painting as Model* (Cambridge, Mass.: MIT Press, 1990; paperback edition, 1993), pp. 157–86.
2. Piet Mondrian, "The New Plastic in Painting," in Harry Holtzman and Martin S. James, eds., *The New Art—The New Life: The Collected Writings of Piet Mondrian* (Boston: G.K. Hall, 1986), p. 31.

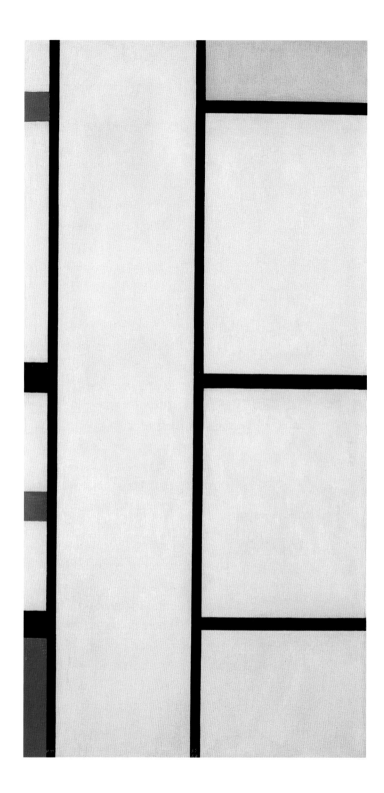

PIET MONDRIAN
Dutch, 1872–1944

Composition with Red, Yellow, and Blue [formerly *Composition No. III Blanc-Jaune* (Composition No. III White-Yellow)]
1935–42
oil on canvas
39 3/4 x 20 1/8 in. (101 x 51.1 cm)

Purchased through a gift of Phyllis Wattis, 98.294

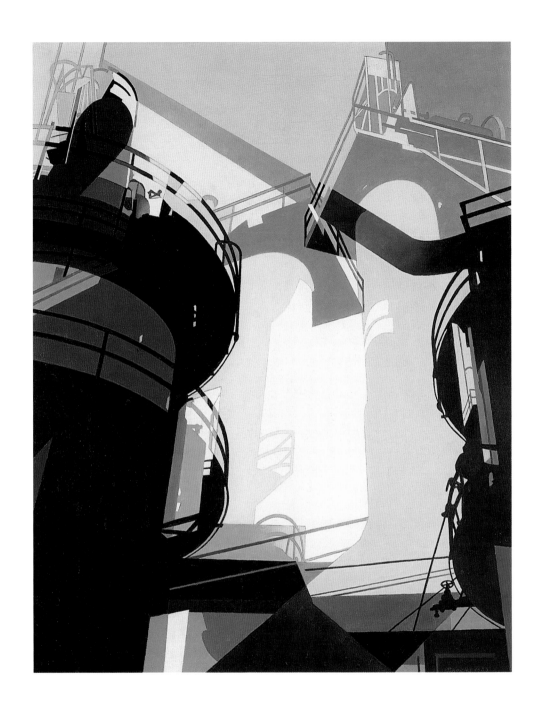

CHARLES SHEELER
American, 1883–1965

Aerial Gyrations
1953
oil on canvas
23 ⅝ x 18 ⅝ in. (60 x 47.3 cm)

Mrs. Manfred Bransten Special Fund
purchase, 74.78

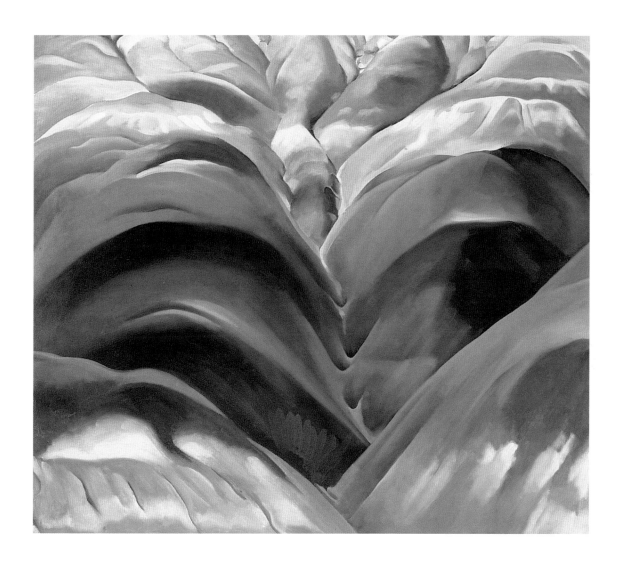

GEORGIA O'KEEFFE
American, 1887–1986

Black Place I
1944
oil on canvas
26 x 30 ⅛ in. (66 x 76.5 cm)

Gift of Charlotte Mack, 54.3536

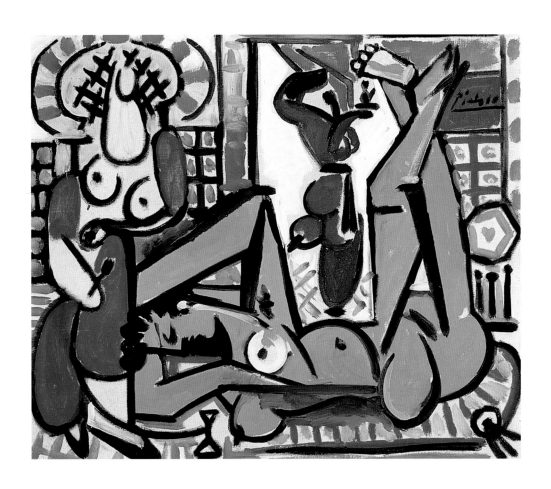

PABLO PICASSO
Spanish, 1881–1973

Les Femmes d'Alger
(Women of Algiers)
1955
oil on canvas
18 1/8 x 21 5/8 in. (46 x 54.9 cm)

Gift of Wilbur D. May, 64.4

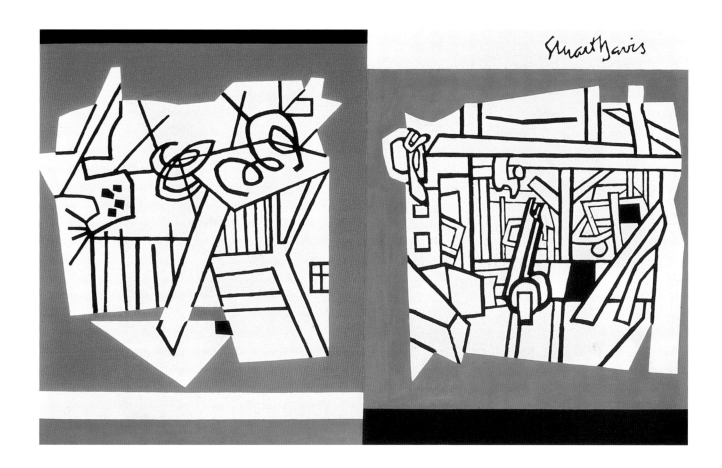

STUART DAVIS
American, 1894–1964

Deuce
1954
oil on canvas
26 x 42 ¼ in. (66 x 107.3 cm)

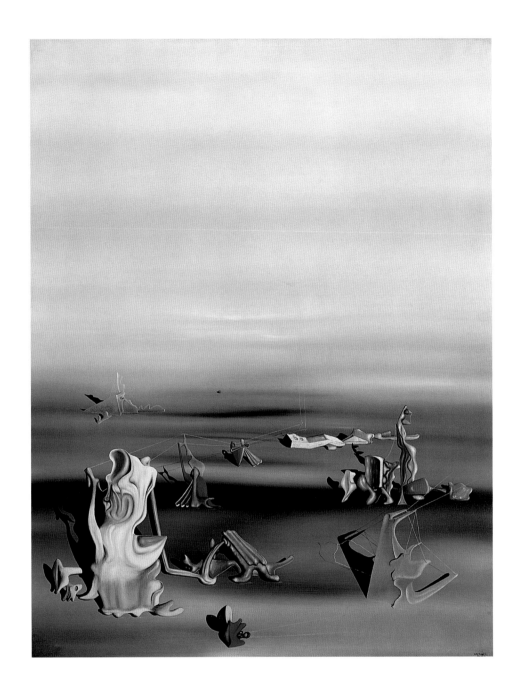

YVES TANGUY
French, 1900–1955

Arrières-pensées
(Second Thoughts)
1939
oil on canvas
36 1/8 x 29 1/4 in. (91.8 x 74.3 cm)

William L. Gerstle Collection;
William L. Gerstle Fund purchase,
52.4155

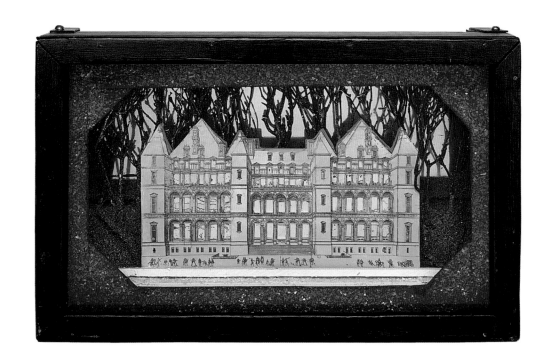

JOSEPH CORNELL
American, 1903–1972

Untitled (Pink Palace)
ca. 1946–48
wooden box construction: photo-
stat with ink wash, wood, mirror,
plant material, and artificial snow
8 ⁵/₈ x 14 ¹/₄ x 4 ³/₈ in.
(21.9 x 36.2 x 11.1 cm)

Purchased through gifts of Mr. and Mrs.
William M. Roth and William L. Gerstle,
82.328

Although often grouped with Surrealist artists such as Salvador Dalí, Max Ernst, and Yves Tanguy, René Magritte took a somewhat different approach, evoking the strangeness and ambiguity latent in reality rather than creating fantasy imagery. "I don't paint visions. To the best of my capability, by painterly means, I describe objects—and the mutual relationship of objects—in such a way that none of our habitual concepts or feelings is necessarily linked with them."[1] In *Les Valeurs personnelles* (1952) Magritte presents a room furnished with a bed, armoire, and rugs and occupied by familiar objects such as a comb, wineglass, shaving brush, match, and bar of soap. Familiarity and comfort, however, end with our identification of the objects on view. These unassuming props of everyday life are given human proportions, creating a sense of disorientation and incongruity that is enhanced by the inversion of inside and outside occasioned by the skyscape on the walls of the room. The familiar has become unfamiliar, the normal, strange; Magritte has succeeded in creating a paradoxical world that is "a defiance of common sense."[2]

RENÉ MAGRITTE
Les Valeurs personnelles
(Personal Values)

The remarkable technical execution of *Les Valeurs personnelles* contributes to its power as an image. Painting during the heyday of abstraction, particularly American Abstract Expressionism, Magritte insisted on mimesis, or the attempt to paint things as they are. He used a method of representation associated with realism and his own highly acclaimed skill to achieve an accuracy of depiction that strengthens the disconcerting effect as the objects take on an eerie life of their own. For Magritte there was no need to resort to abstraction, since the realism of everyday life contained more than enough mystery. Magritte's fascination with the possibilities inherent in objects such as those depicted in *Les Valeurs personnelles* perhaps explains why he adopted the title his friend Paul Nougé proposed for the painting, a title that elevates the objects to the level of abstract values.

In the half-century since Magritte painted this work, a diverse group of artists has continued to develop the formal and theoretical concerns explored in the painting. Connections have been drawn to Jasper Johns and Robert Rauschenberg, Pop artists such as Claes Oldenburg, and Conceptual artists such as Marcel Broodthaers and Joseph Kosuth. More recently, contemporary artist Mona Hatoum has used a subtlety and restraint evocative of Magritte to expose the gendered nature of domestic objects, thereby sharing Magritte's goal of making the familiar strange and causing the viewer to reevaluate basic assumptions about the world around us. —TM

1. Magritte, quoted in Suzi Gablik, *Magritte* (Greenwich, Conn.: New York Graphic Society Ltd., 1970), p. 13.
2. Ibid., p. 14.

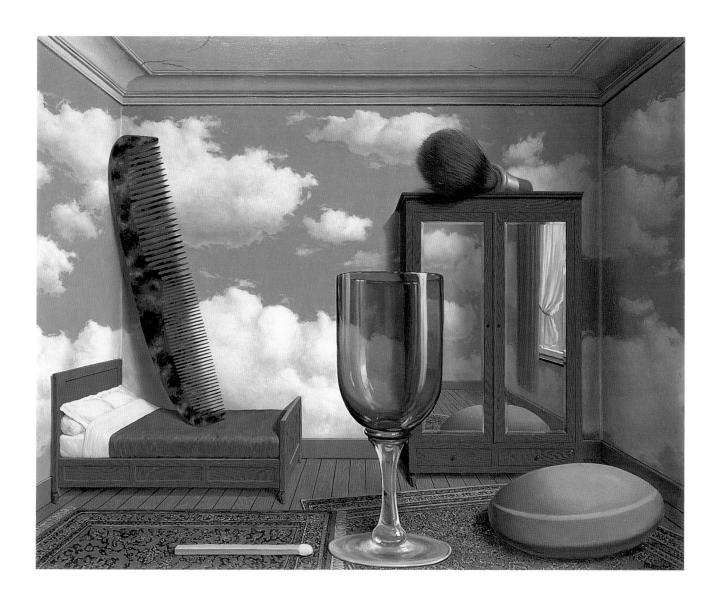

RENÉ MAGRITTE
Belgian, 1898–1967

Les Valeurs personnelles
(Personal Values)
1952
oil on canvas
31 1/2 x 39 3/8 in. (80 x 100 cm)

JACKSON POLLOCK
Guardians of the Secret

Probably the most well-known artist in American history, Jackson Pollock revolutionized painting in 1947 when he completed his first "drip" work. In an attempt to free the canvas from the confines of the stretcher and to physically involve himself more wholly in a painting's creation, Pollock placed the canvas directly on the floor and began pouring, dripping, and sieving paint rather than relying on controlled brushwork. The resulting works were complicated, allover abstractions of carefully layered lines of paint, entangled and woven together into beautiful yet raucous compositions. The quintessential "action painter," Pollock and his fellow Abstract Expressionists were championed by contemporaneous critics, notably Harold Rosenberg, who felt that pure abstraction was the epitome of artistic expression because it stemmed from individual (that is, "heroic") psychic states.

Pollock's journey toward complete abstraction, however, encompassed myriad experiments with a variety of painting styles and techniques. Immediately preceding the drip paintings, he completed his first mature body of work. *Guardians of the Secret* (1943) is a particularly important painting within this group as it established a vocabulary of personal symbols and represented a stylistic milestone for the artist, moving away from his early representational roots (he had studied with Thomas Hart Benton) and toward the gestural abstractions that became his hallmark.

At one point during its evolution, *Guardians of the Secret* was a "group portrait of the Pollock family at the dinner table."[1] Eventually, however, the aspects of portraiture were submerged and the canvas was reworked, leaving only two mysterious figures (one on either side of the central rectangle or "table") and a dog (lower center) gathered at the feast. Stylistically, the piece straddles the line between figuration (represented by the three "guardians" described above) and abstraction (the "secret" of the title, represented pictorially by the confusing amalgam of strange symbols and hieroglyphs in the central and upper portions of the canvas, which when rotated 180 degrees appear simply as upside-down stick figures). These symbols have sometimes been interpreted as arising out of Pollock's exploration of Jungian archetypes during a period in which he was undergoing psychoanalysis. The archetypal figures, then, would suggest Pollock's desire to come to terms with his own private demons.

In the same year it was painted, *Guardians of the Secret* was exhibited at Pollock's first one-person show, held at Peggy Guggenheim's Art of This Century gallery in New York. In 1945 the painting was shown at the San Francisco Museum of Art (now SFMOMA), this time in Pollock's first solo museum exhibition, immediately after which it was acquired for the Museum's collection. —MH

1. See Steven Naifeh and Gregory White Smith, *Jackson Pollock: An American Saga* (New York: HarperCollins, 1991), p. 456.

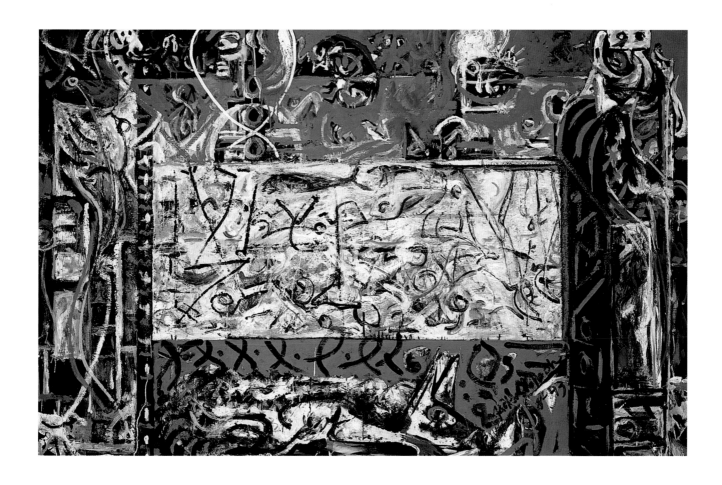

JACKSON POLLOCK
American, 1912–1956

Guardians of the Secret
1943
oil on canvas
48 3/8 x 75 3/8 in. (122.9 x 191.5 cm)

Albert M. Bender Collection; Albert M.
Bender Bequest Fund purchase, 45.1308

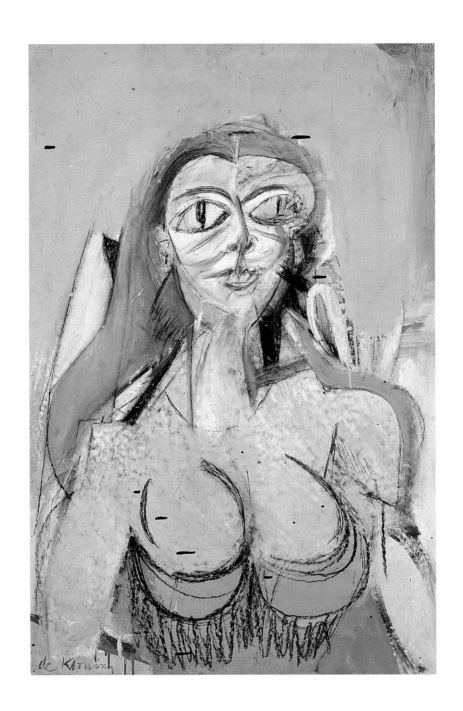

WILLEM DE KOONING
American, born Netherlands,
1904–1997

Woman
1950
oil on paper mounted on Masonite
36⅝ x 24½ in. (93 x 62.2 cm)

Purchase, 68.69

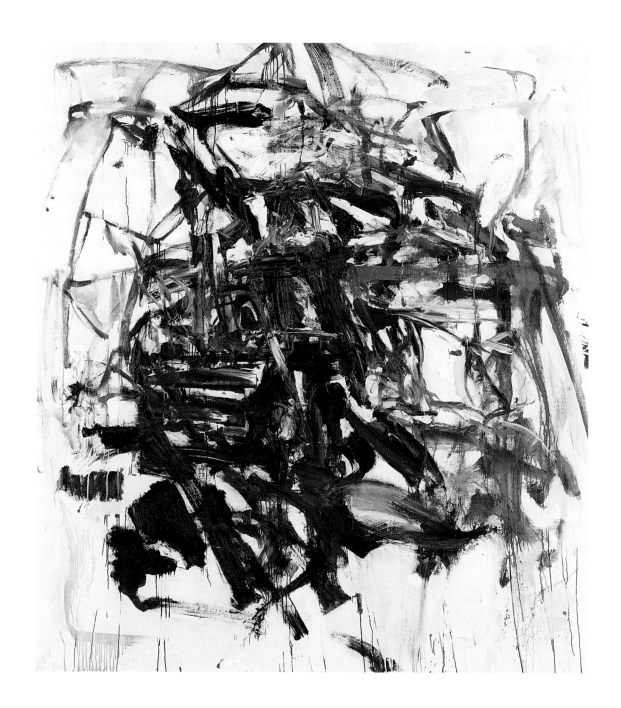

JOAN MITCHELL
American, 1926–1992

Untitled
ca. 1960
oil on canvas
82 ³/₈ x 74 ¹/₂ in. (209.3 x 189 cm)

Gift of Sam Francis, 79.440

ROBERT RAUSCHENBERG
Collection

Aptly titled, Robert Rauschenberg's *Collection* (1954) presents an array of photographs, fabric scraps, newspaper clippings, wood blocks, paint drips, shapes, colors, and textures jostling with one another and jockeying for position on one vibrant canvas. Scribbled paint strokes blur the punchlines of comics, drips of white paint collide with a thick red line squeezed right from the paint tube, and bits of headlines such as "Dandruff may be the beginning of baldness" jump out amid abstract patches of pink, red, and yellow. *Collection* is one of the first in a group of works made in the 1950s that Rauschenberg termed "combines," addressing the quandary of placing such work within more clearly defined media categories such as painting, sculpture, collage, or assemblage. Incorporating elements of each, Rauschenberg's *Collection* resonates with the eighteenth- and nineteenth-century practice of gentlemen collectors accumulating objects into a *Wunderkammer,* or room of marvels. Perhaps not surprisingly, when asked to identify his greatest fear, Rauschenberg responded, "That I might run out of world."[1]

Coexisting with the random, improvisatory nature of *Collection* is an equally strong logical presence. The picture is divided into nine sections—three distinct vertical panels marked by three horizontal bands of pictorial activity—and the image is almost quartered by the intersection of the red and white lines of paint mentioned above. The middle horizontal band holds the crux of accumulated objects, and thus the most activity. The lower horizontal band retains an emphasis on bands of color similar to abstract works by painters such as Morris Louis and a repetitive logic that foreshadows minimalists such as Donald Judd. The upper band of geometric collages of fabric and paint maintains a cool neutrality.

Rauschenberg's use of found objects and everyday materials in the combines to invade and subvert the pristine nature of the picture plane has both elicited critical attention and influenced a variety of artists, from Joseph Beuys and Andy Warhol to Bruce Nauman and Sigmar Polke. Equally important, however, is his respect for the integrity of the picture plane in these works, a respect that stems from his admiration for and emulation of the generation of Abstract Expressionist painters that came before him, including Willem de Kooning and Clyfford Still. Although the use of banal objects draws inspiration from the readymades of Marcel Duchamp, the improvisatory gestures employed in applying both paint and object to *Collection* owe much to the generation of "action" painters to which Still and de Kooning belonged. —TM

1. Rauschenberg, quoted in Robert Rauschenberg and Donald Saff, "A Conversation about Art and ROCI," in *Rauschenberg Overseas Culture Interchange,* exh. cat. (Washington, D.C.: National Gallery of Art, 1991), p. 179.

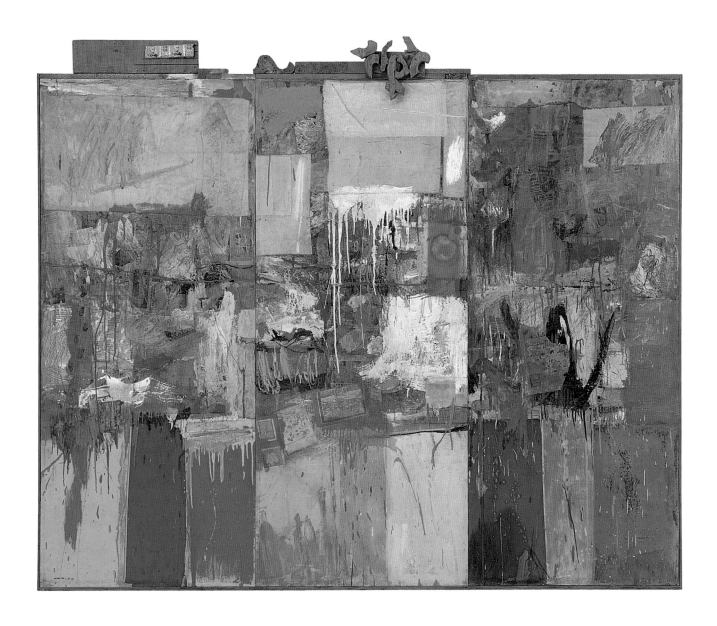

ROBERT RAUSCHENBERG
American, born 1925

Collection [formerly *Untitled*]
1954
oil, paper, fabric, and metal on wood
80 x 96 x 3 ½ in. (203.2 x 243.8 x 8.9 cm)

Gift of Harry W. and Mary Margaret Anderson, 72.26

Art ought to be a troublesome thing. And one of my reasons for painting representationally is that this makes for much more troublesome pictures.[1]

DAVID PARK
Torso

Thick, raw strokes of shockingly bright color animate David Park's *Torso* (1959), depicting a nude figure in front of an ambiguous background. Despite the easily recognizable, sculptural solidity of the human form, large areas of *Torso* slip into pure abstraction, conveying only the path of Park's brush itself pulling a heavy load of paint across the surface of the canvas. A sense of bright sunlight saturates the scene, signaled by white highlights on the figure's upper body and arm, and the white patch at the top of the canvas. Hand on hip, staring placidly out at the viewer, Park's figure possesses an eerie quietude that is all the more remarkable considering the battle between representation and abstraction that is being waged across the entire surface of the painting.

After working in a representational style early in his career, Park, like most established Bay Area painters of his day, gravitated toward nonrepresentation in the mid-1940s. A period of approximately four years as an abstract painter ended abruptly in 1949, when, in an event that became a Bay Area legend, Park disposed of his abstract paintings at the Berkeley city dump. In 1951 began exhibiting pictures that joined the flamboyant brushwork and pure painterliness of Abstract Expressionism with a commitment to representational imagery and the human figure. By the end of the decade, artists such as Elmer Bischoff, Richard Diebenkorn, Nathan Oliveira, and James Weeks had joined Park to create a style now known as Bay Area Figurative, perhaps the region's most significant contribution to twentieth-century art.

Torso is a study in contrasts that shows Park at the height of his powers. The face is sketched in with a few recklessly confident brush strokes, and the volume of the figure is conveyed with a bare minimum of color and broad brushwork. Against all logic and expectation, bilious greens, muddy reds, and glaring whites manage to convey a sense of atmosphere and pulsating energy in the unreadable background. A few dark smudges serve as eyes, while some well-placed swatches of red and dark brown are enough to express the curve and weight of a belly. Like a snapshot, *Torso* seems fast and offhand, from its cropped composition to the apparent speed of the brushwork. Yet for all its verve and energy, *Torso* possesses a timeless quality and an air of tranquility and ease. Representative of Park's finest paintings, it is a balancing act between contradictory impulses, which the artist resolves brilliantly despite the "troublesome" nature of the task he set for himself. —JSW

1. Park, quoted in Paul Mills, *Contemporary Bay Area Figurative Painting,* exh. cat. (Oakland, Calif.: The Oakland Museum, 1957), p. 7.

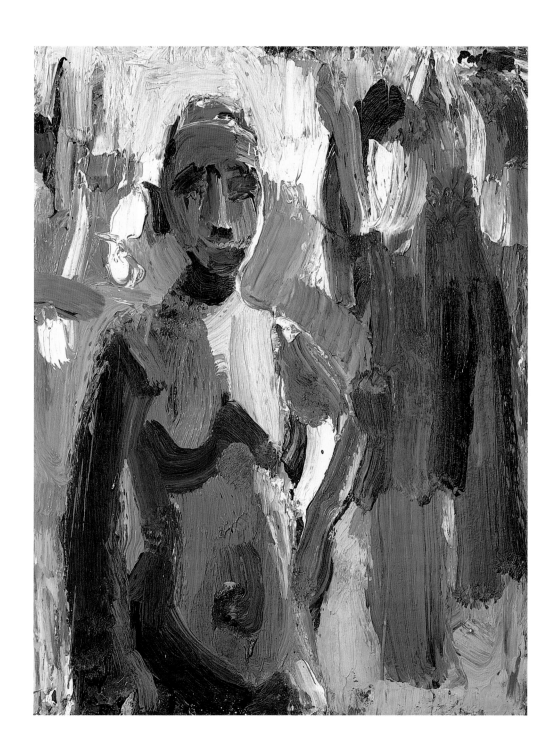

DAVID PARK
American, 1911–1960

Torso
1959
oil on canvas
36 ³/₈ x 27 ³/₄ in. (92.4 x 70.5 cm)

Gift of the Women's Board, 60.7426

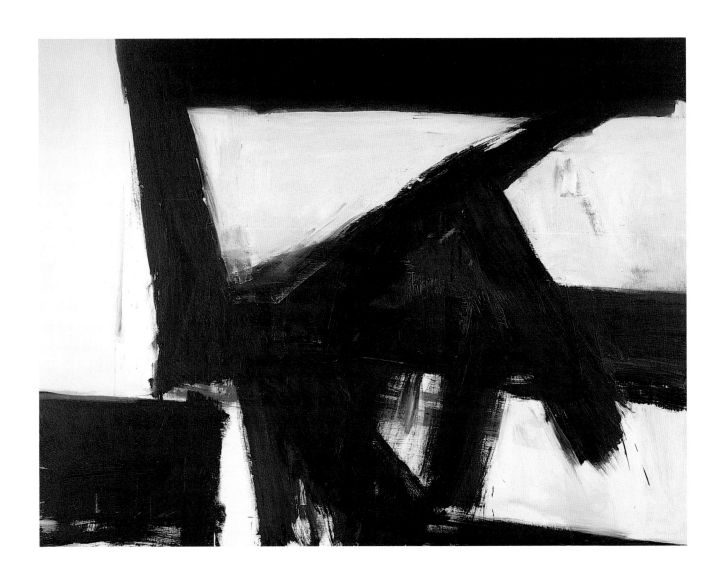

FRANZ KLINE
American, 1910–1962

Lehigh V Span
1959–60
oil on canvas
60 1/4 x 80 in. (153 x 203.2 cm)

Gift of the Hamilton-Wells Collection,
84.186

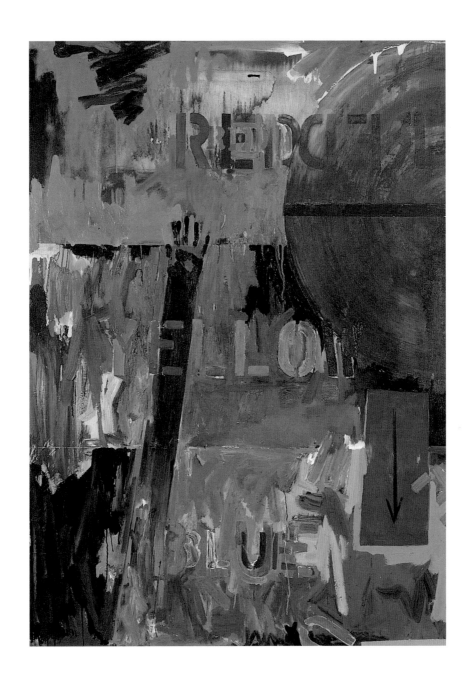

JASPER JOHNS
American, born 1930

Land's End
1963
oil on canvas with stick
67 x 48 ¼ in. (170.2 x 122.6 cm)

Gift of Harry W. and Mary Margaret
Anderson, 72.23

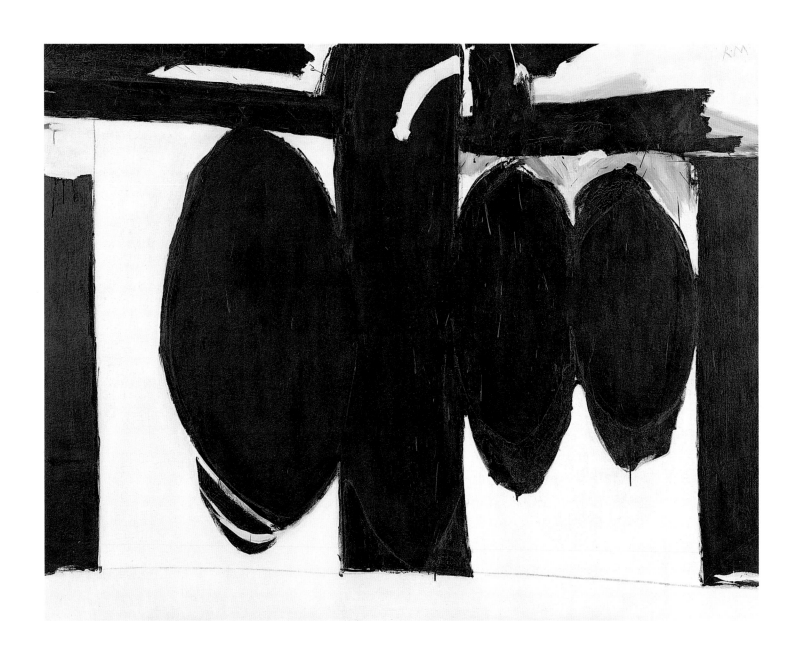

ROBERT MOTHERWELL
American, 1915–1991

Elegy to the Spanish Republic, No. 57
1957/60
oil on canvas
84 x 109 ¹/₈ in. (213.4 x 277.2 cm)

Purchased through a gift of Phyllis Wattis, and gift
of Gardiner Hempel, 94.383

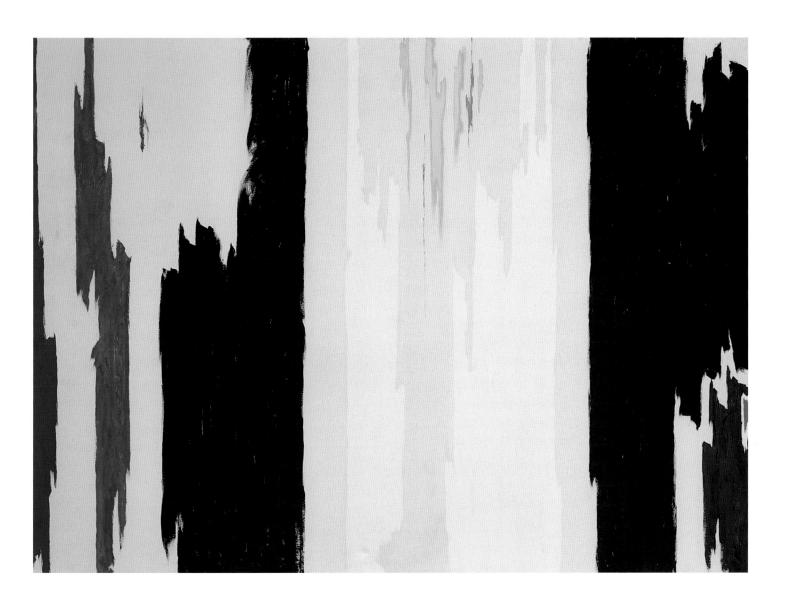

CLYFFORD STILL
American, 1904–1980

Untitled
1960
oil on canvas
113 x 156 in. (287 x 396.3 cm)

Gift of Harry W. and Mary Margaret
Anderson, 74.19

MARK ROTHKO
No. 14, 1960

Mark Rothko's signature imagery, for which he is now recognized as one of the most important members of the Abstract Expressionist movement in postwar America, was firmly defined by the early 1950s. In his works dating from this period until the end of the 1960s, Rothko established himself as a master of color relationships, dividing the canvas into two or three color fields of varying sizes that seem to float atop one another, approaching, but never quite melding together. Diffused as opposed to hard-edged, these expanses of carefully balanced color have the ability to effuse out of the canvas itself, enveloping the viewer in an atmosphere of charged emotion. As the artist put it, his goal in painting was "the elimination of all obstacles between the painter and the idea and between the idea and the observer."[1] This aim of heightening a painting's communicative ability by paring it down to a "simple expression"[2] is assisted by the smooth, unworked appearance of the surface of the painting itself, a guise that effectively masks the "action" of Abstract Expressionist action painting. Viewers stand entranced by the glowing colors, as the idea, be it serene or tumultuous, permeates the visual field.

No. 14, 1960, one of the most beautiful and hypnotic works from Rothko's œuvre, is exemplary in its ability to allow color to serve as the vessel of content. Here, the bright, pulsating orange of the upper rectangle hovers over, sometimes seeming to radiate from behind, the rich yet cooler field of blue at the bottom. The combination of these two austere fields suggests a pictorial referent in nature—perhaps a fiery sunset over a darkening ocean, or a night sky lit up by flames—but the immediate effect on the viewer is more visceral. We feel our presence in the picture's space, which can only be viewed as a continuum "outside of the picture plane, on some meeting ground between the picture and the viewer."[3] As the diffuse edges of the color fields float out from the maroon ground and encompass the observer, the whole environment of the work becomes palpable.

This painting was one of fifty-four works chosen by Rothko to comprise his first major one-person show at the Museum of Modern Art, New York, in 1961. In this exhibition, the artist designed the installation himself, heightening the effect of the color fields by muting the lighting in the galleries and hanging the works relatively close to one another so that the paintings "appeared to glow in the dark."[4] The emotional power of Rothko's work is amplified when several canvases occupy a single room, a notable example being the Rothko Chapel in Houston, Texas. Viewed in such an intimate setting, Rothko's paintings exude their full meditative power. —MH

1. Rothko, quoted in Diane Waldman, "Mark Rothko: The Farther Shore of Art," *Mark Rothko, 1903–1970: A Retrospective,* exh. cat. (New York: Solomon R. Guggenheim Museum, 1978), p. 61.
2. Rothko, with Adolph Gottlieb and Barnett Newman, "Letter to Edward Alden Jewell," *New York Times,* 13 June 1943, sec. 2, p. 9.
3. Peter Selz, *Mark Rothko,* exh. cat. (New York: Museum of Modern Art, 1961), p. 12.
4. Waldman, "The Farther Shore of Art," p. 66

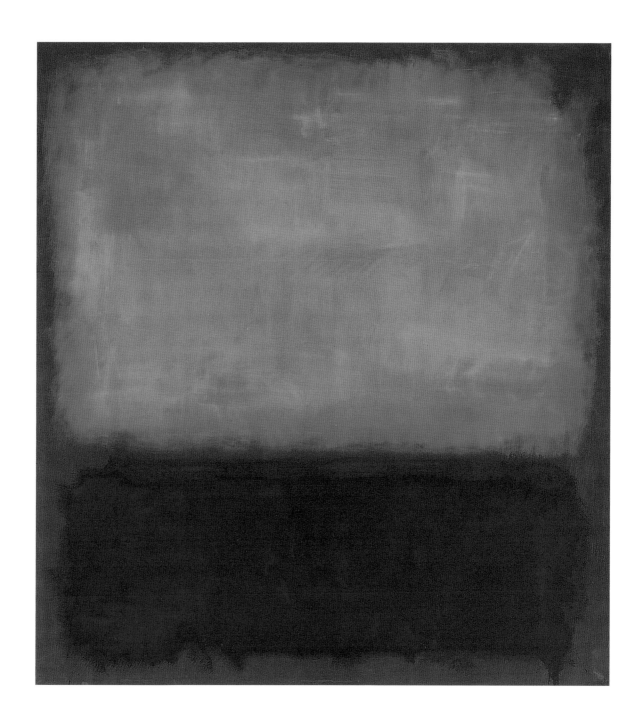

MARK ROTHKO
American, born Russia, 1903–1970

No. 14, 1960
1960
oil on canvas
114 ¹/₂ x 105 ⁵/₈ in. (290.8 x 268.3 cm)

Helen Crocker Russell Fund purchase, 97.524

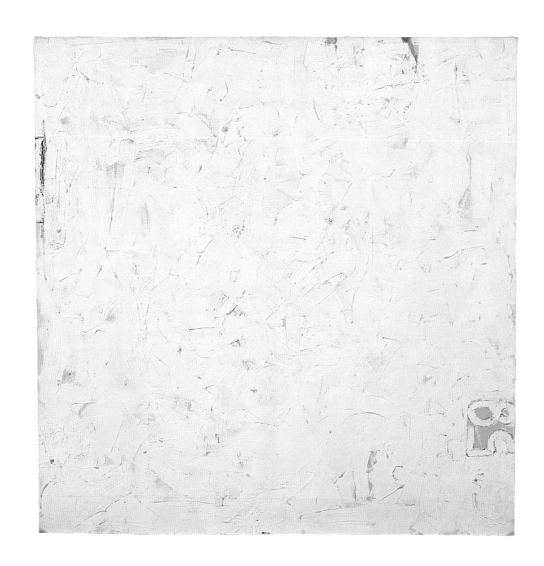

ROBERT RYMAN
American, born 1930

Untitled
1958
oil on canvas
43 x 43 in. (109.2 x 109.2 cm)

Purchased through a gift of Mimi
and Peter Haas, 98.110

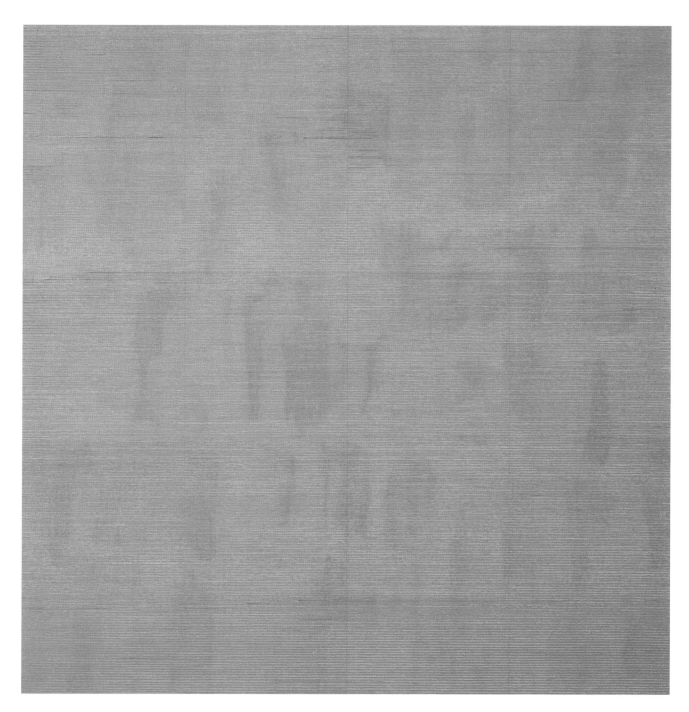

AGNES MARTIN
American, born Canada, 1912

Falling Blue
1963
oil and pencil on canvas
71 7/8 x 72 in. (182.6 x 182.9 cm)

Gift of Mr. and Mrs. Moses Lasky, 74.96

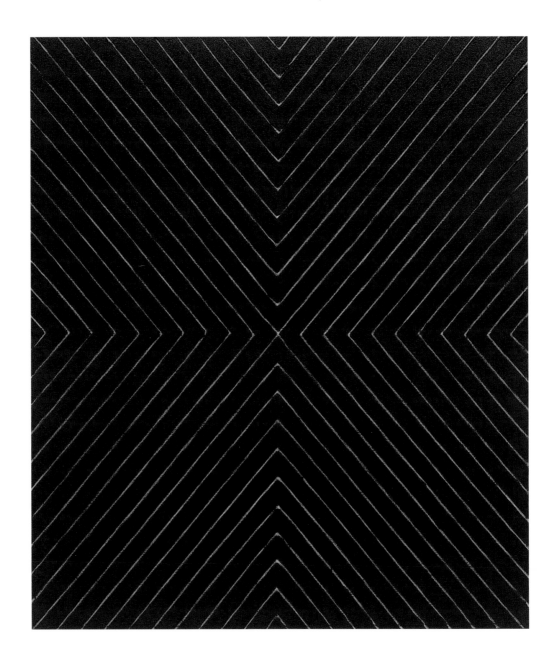

FRANK STELLA
American, born 1936

Zambezi
1959
enamel on canvas
90³/₄ x 78³/₄ in. (230.5 x 200 cm)

Gift of Harry W. and Mary Margaret Anderson,
2001.542

ELLSWORTH KELLY
American, born 1923

Red White
1962
oil on canvas
80 1/8 x 90 1/4 in. (203.5 x 229.3 cm)

T. B. Walker Foundation Fund purchase, 66.3

A leading figure of American Pop art, Andy Warhol drew upon the iconography of the mass media and post–World War II consumerist culture to comment on contemporary society. Born Andrew Warhola in Pittsburgh, he began his career as a commercial artist, designing advertisements and window displays for department stores and illustrations for popular magazines such as *Glamour* and *Harper's Bazaar*. This early commercial work would significantly influence his choice of subjects and techniques in subsequent artworks, which included paintings, prints, sculptures, and films.

ANDY WARHOL
National Velvet

Emerging during the heyday of Abstract Expressionism, which exalted painting as an intensely emotional and sublime activity, Warhol turned instead to impersonal industrial materials and subjects derived from popular culture: commonplace commercial objects such as Campbell's soup cans; head shots of Hollywood celebrities such as Marilyn Monroe; and topical images from the mass media such as footage of race riots and newspaper photos of the grieving Jacqueline Kennedy. Rejecting traditional artistic values of originality and the handmade, Warhol hired assistants to execute his works, turning the art-making process into a form of manufacturing (he famously remarked, "I want to be a machine"). His Manhattan studio was appropriately known as the Factory and became a notorious nightspot for actors, celebrities, musicians, aspiring artists, and other hangers-on in the 1960s. No stranger to the art of self-promotion, Warhol achieved an unprecedented celebrity status both in and beyond the art world.

Warhol's fascination with the machinations of Hollywood and fame is apparent in *National Velvet* (1963), an iconic work made during the height of his career. The piece exemplifies his use of photo-silkscreening to create serial imagery. The source image for this work is a film still of a young Elizabeth Taylor from the 1944 movie of the same title and is rendered on a large silver-painted canvas, evoking Hollywood's proverbial silver screen. Warhol and his assistants at the Factory laid a cut stencil of the film still on the canvas and then "painted" the image by applying silkscreen ink with a squeegee. Warhol welcomed the variations and imperfections inherent in the silkscreening process; the repetition of the image in several rows and its gradual fading creates the effect of a passing frame in a flickering film reel, and implies perhaps the fleeting nature of fame. This monumentally sized work serves to both immortalize its subject and critique the commodified world of pop culture. —CK

ANDY WARHOL
American, 1928–1987

National Velvet
1963
silkscreen ink on synthetic polymer
paint on canvas
136 ³/₈ x 83 ¹/₂ in.
(346.4 x 212.1 cm)

Accessions Committee Fund: gift of
Barbara and Gerson Bakar, Doris and
Donald G. Fisher, Evelyn and Walter Haas,
Jr., Mimi and Peter Haas, Byron R. Meyer,
Helen and Charles Schwab, Danielle and
Brooks Walker, Jr., and Judy C. Webb;
Albert M. Bender Fund; Tishler Trust;
Victor Bergeron Fund; Members'
Accessions Fund; and gift of The Warhol
Foundation for the Visual Arts, Inc.,
93.376

ROY LICHTENSTEIN
American, 1923–1997

Rouen Cathedral Set V
1969
oil and acrylic on canvas
63 1/8 x 126 1/4 in. (160.3 x 320.7 cm)

Gift of Harry W. and Mary Margaret Anderson,
92.266.A–C

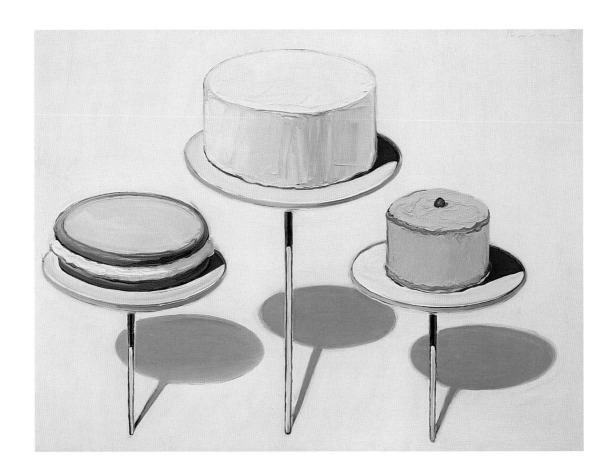

WAYNE THIEBAUD
American, born 1920

Display Cakes
1963
oil on canvas
28 x 38 in. (71.2 x 96.6 cm)

Mrs. Manfred Bransten Special Fund
purchase, 73.52

RICHARD DIEBENKORN
American, 1922–1993

Ocean Park #54
1972
oil on canvas
100 x 81 in. (254 x 205.7 cm)

Gift of Friends of Gerald Nordland,
72.59

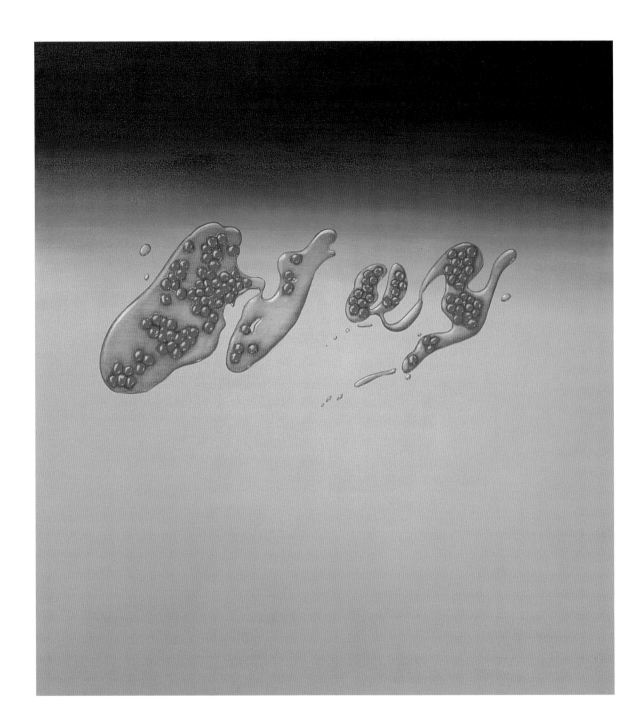

ED RUSCHA
American, born 1937

"Hey"
1968–69
oil on canvas
60 x 55 in. (152.4 x 139.7 cm)

Bequest of Alfred M. Esberg, 85.416

ROBERT BECHTLE
American, born 1932

Alameda Gran Torino
1974
oil on canvas
48 x 69 in. (121.9 x 175.3 cm)

T. B. Walker Foundation Fund purchase
in honor of John Humphrey, 74.87

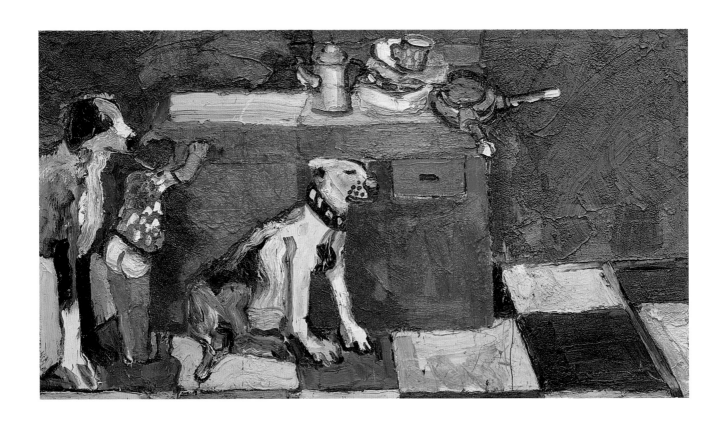

JOAN BROWN
American, 1938–1990

Noel in the Kitchen
ca. 1964
oil on canvas
60 x 108 in. (152.4 x 274.3 cm)

Bequest of Dale C. Crichton, 89.79

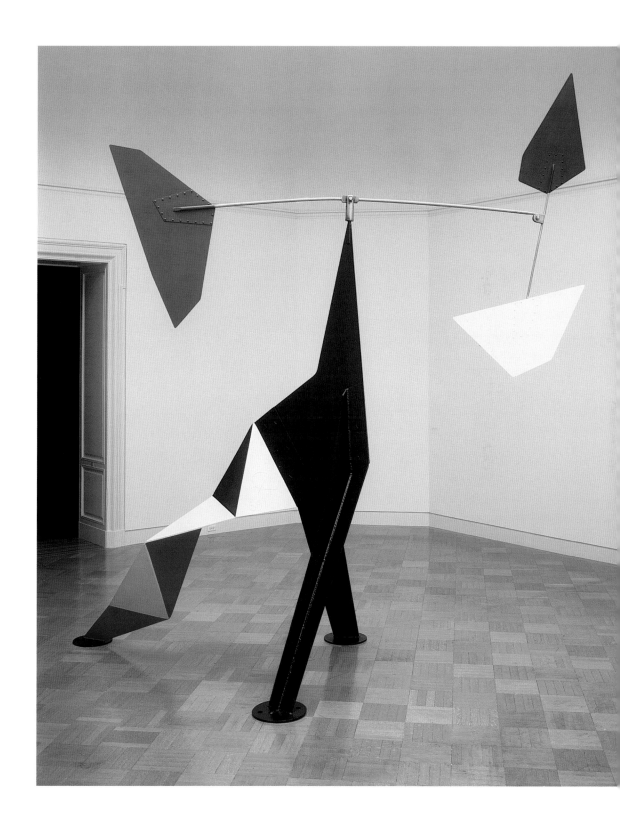

ALEXANDER CALDER
American, 1898–1976

Big Crinkly
1969
painted steel
150 x 97 x 76 in.
(381 x 246.4 x 193 cm)

Gift of Rita B. Schreiber in loving memory
of her husband, Taft Schreiber, 89.118

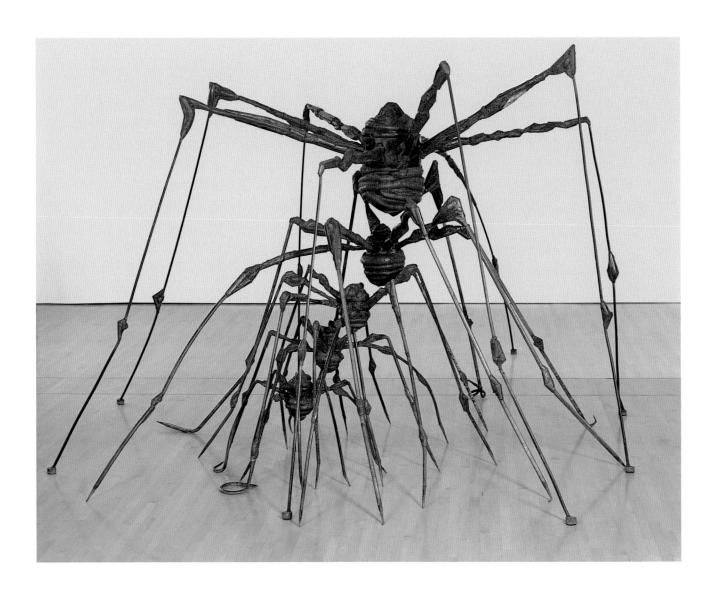

LOUISE BOURGEOIS
American, born France, 1911

The Nest
1994
steel
101 x 189 x 158 in.
(256.5 x 480 x 401.3 cm)

Purchased through the Agnes E. Meyer
and Elise S. Haas Fund and the gifts of
Doris and Don Fisher, Helen and Charles
Schwab, and Vicki and Kent Logan,
98.193

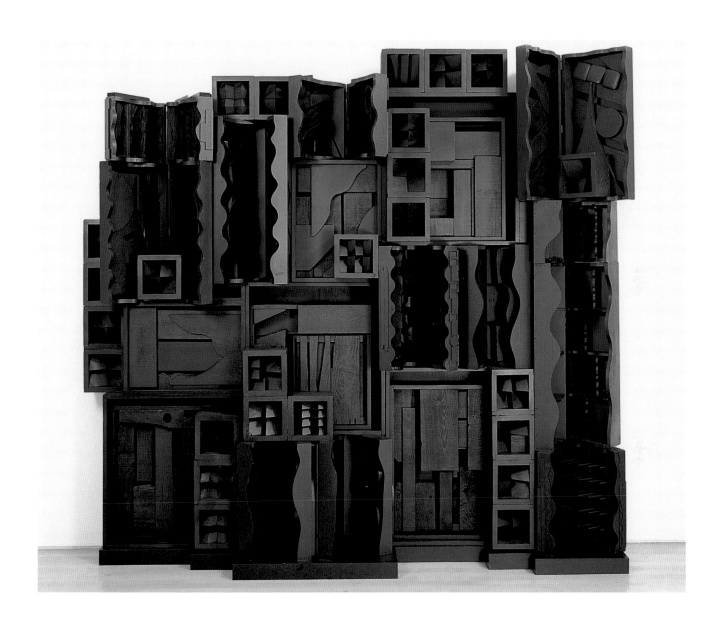

LOUISE NEVELSON
American, 1889–1988

Cascade
1964
painted wood
100 ½ x 109 x 17 ½ in.
(255.3 x 276.7 x 44.5 cm)

Gift of an anonymous donor, 93.480

Although she died at the young age of thirty-four, Eva Hesse stands among the most important and influential figures in recent art. *Untitled or Not Yet* (1966) demonstrates her sculptural process of accumulating everyday materials and assembling them in unexpected configurations. The conjunction of opposites was one of Hesse's favorite tropes, and *Untitled or Not Yet* shows her striking use of texture, form, and color. Nine white spheres hang as if fished out of the air and then hung up to dry. The dark grids of the bags contrast with the creamy globular insides, and the whole dripping bunch is nailed unceremoniously to the wall.

This work appears to reveal precisely what it is and how it was made: crumpled polyethylene sheets placed inside hanging net bags. However, wrapped inside the plastic is white tissue paper, lending the balls an opacity, and within the paper hide small fishing weights. The casual droop of these bags did not happen by accident. Hesse created a related group of net works in which the balls are much more structured and stiff, thereby generating a greater tautness in the bags that contain them. In *Untitled or Not Yet,* however, tension is replaced with ease, as the bags exert slight pressure on the malleable polyethylene.

Like many of Hesse's works, *Untitled or Not Yet* is a variable piece, and can be installed in a multitude of formations (although most often, the teardrop-shaped bags are echoed by a teardrop-shaped grouping). The net bags can overlap or clump together, they can jut out in a cluster from the wall, or they can dribble down in a loose, spread-out arrangement. This flexibility opens up a range of associative metaphors: the piece has organic as well as industrial analogues. The forms might appear testicular or breastlike, but they also resemble more cellular, microscopic parts of the body, such as lipids and tissues. However, the transparency of Hesse's process ensures that the shapes ultimately remain what they are—combines of ball, bag, and nail—and they resist overt anthropomorphizing.

Deftly combined, the materials nonetheless retain their contradictions. The dull string of the bags—dyed a rich brown—contrasts with the glistening plastic. Each of the nine bags is subtly distinctive, yet their repetition voids their individuality. As in all of her strongest work, Hesse orchestrates opposing elements: accumulation/singularity, line/shape, enclosure/exposure, geometry/organicism. —JBW

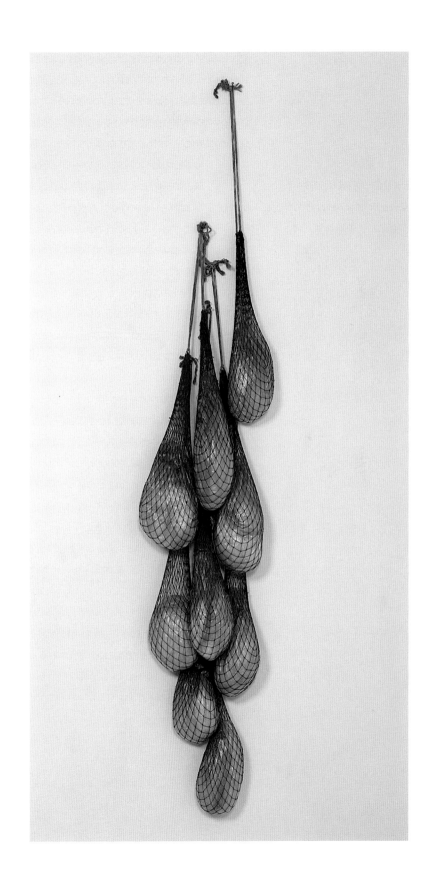

EVA HESSE
American, born Germany, 1936–1970

Untitled or Not Yet
1966
dyed fishnet bags, clear polyethylene,
paper, metal weights, and cotton
string
71 x 15 ¹/₂ x 8 ¹/₄ in.
(180.4 x 39.37 x 21 cm)

Purchased through a gift of Phyllis Wattis,
97.513.A–I

BRUCE NAUMAN

Wax Impressions of the Knees of Five Famous Artists

Considered by many to be the central figure of contemporary American art, Bruce Nauman has produced an eclectic body of work that defies any one label. *Wax Impressions of the Knees of Five Famous Artists* (1966) is an important example of his early work and indicative of his wide-ranging stylistic influences, from post-Minimalism to proto-Conceptualism. It dates from a pivotal period in Nauman's career when he abandoned painting and began exploring the properties of materials in space—gravity, flexibility, contingency—using latex rubber, felt, and fiberglass.

During these first years of sculptural production, Nauman utilized unassuming techniques and worked with things close at hand in his studio. He began to use his own body as an object in his films and videos, photographs, and performances. Taking arbitrary measurements of his limbs or devising neon templates of his torso, he created works out of the banality of his own form. It was Nauman himself who knelt to produce the five knee hollows in this work, but he gave it a self-consciously aggrandizing title that implied the slab was an altar of sorts or had a reliquary function. He later stated in an interview: "I couldn't decide who to get for artists, so I used my own knees. Making the impressions of the knees in a wax block was a way of having a large rectangular solid with marks in it. I didn't want just to make marks in it, so I had to follow another kind of reasoning. It also had to do with trying to make the thing itself less important to look at."[1]

Although his works have an abundance of visual interest, making "the thing itself less important to look at" is key to Nauman's approach. He challenges formal value judgments, choosing instead to promote a denial or evacuation of traditional aesthetics. With *Wax Impressions of the Knees of Five Famous Artists,* he mocks the heroicizing impulses of art history. Nauman did a drawing after making the sculpture in which he provided labels for the "artists," including William T. Wiley and Lucas Samaras, but exhorted himself to "not use Marcel Duchamp." He also penciled in Willem de Kooning's name, but crossed it out and wrote "self" instead. Nauman thus playfully refuted Dada's influence and inserted his own knee into a lineage of sanctified artists.

The act of kneeling conjures a series of associations: some religious, some chivalrous. Here the gesture of prostration is ironically elevated, as if the shapes of the artists' knees were themselves intrinsically interesting. The almost forensic exactitude of the impressions only heightens the absurdity—knee prints are not, after all, fingerprints. The sculpture (bearing his own knees and made of fiberglass, not wax) underscores the arbitrary qualities of language, another of Nauman's favorite themes. *Wax Impressions* embodies some of Nauman's lasting preoccupations: the indexicality of the body, antiformalism, a critical attitude toward art history, and a witty use of language. —JBW

1. Nauman, quoted in Joe Raffaele and Elizabeth Baker, "The Way Out West: Interviews with 4 San Francisco Artists," *Art News* 66 (Summer 1967): 75.

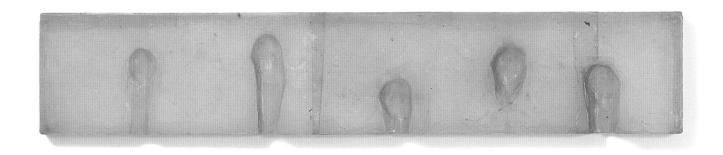

BRUCE NAUMAN
American, born 1941

*Wax Impressions of the Knees
of Five Famous Artists*
1966
fiberglass and polyester resin
15 ⁵/₈ x 85 ¹/₄ x 2 ³/₄ in.
(39.7 x 216.5 x 7 cm)

The Agnes E. Meyer and Elise Stern Haas
Fund and Accessions Committee Fund:
gift of Collectors Forum, Doris and
Donald G. Fisher, Evelyn Haas, Mimi and
Peter Haas, Pam and Dick Kramlich,
Elaine McKeon, Byron R. Meyer, Nancy
and Steven Oliver, Helen and Charles
Schwab, Norah and Norman Stone,
Danielle and Brooks Walker, Jr., and Pat
and Bill Wilson, 96.92

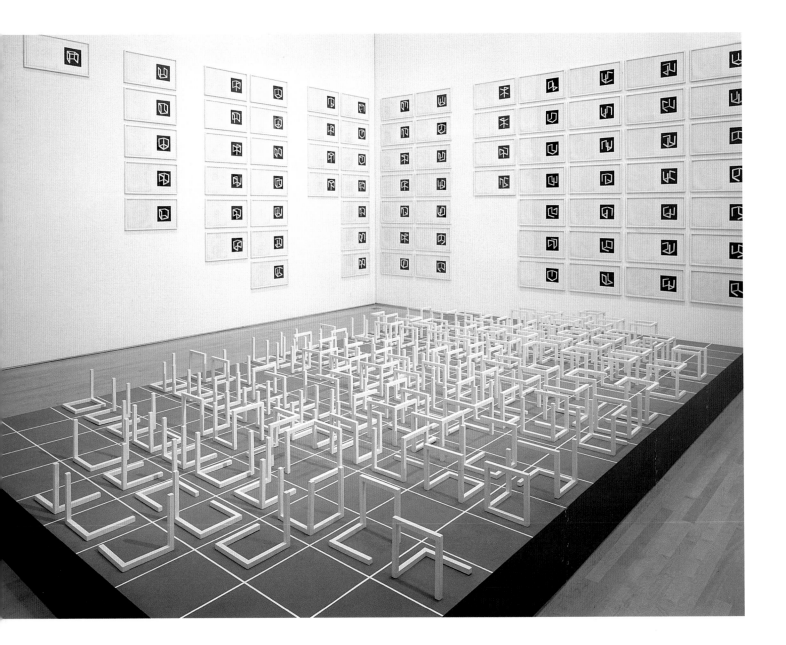

SOL LEWITT
American, born 1928

Incomplete Open Cubes
1974
painted wood structures on a painted wooden base with framed black-and-white
photographs and drawings on paper
dimensions variable

Accessions Committee Fund: gift of Emily L. Carroll and Thomas Weisel, Jean and James E.
Douglas, Jr., Susan and Robert Green, Evelyn Haas, Mimi and Peter Haas, Eve and Harvey
Masonek, Elaine McKeon, the Modern Art Council, Phyllis and Stuart G. Moldaw, Christine and
Michael Murray, Danielle and Brooks Walker, Jr., and Phyllis Wattis, 97.516.A–KKKKKKKKKK

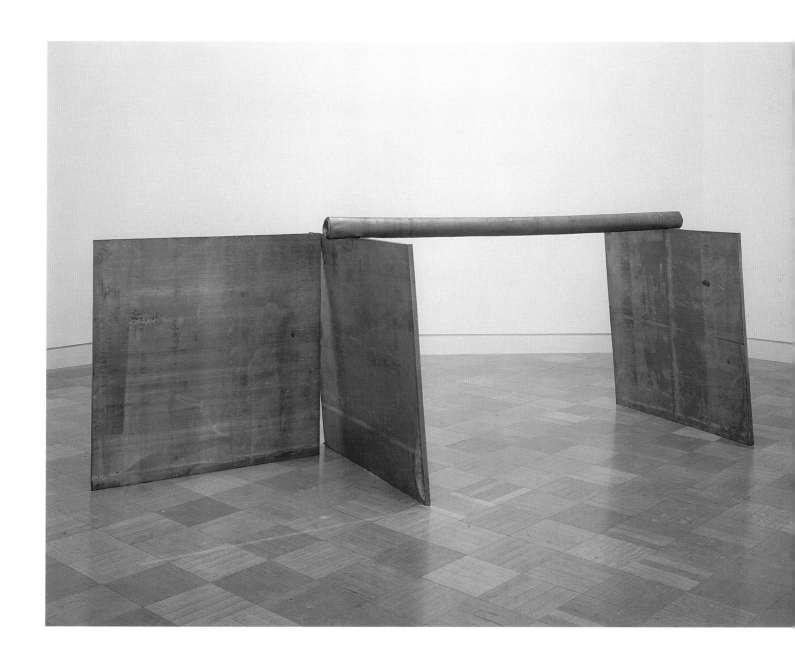

RICHARD SERRA
American, born 1939

Right Angle Plus One
1969
lead antimony
48 x 48 x 1 in.
(121.9 x 121.9 x 2.5 cm)

Purchased through a gift of the
Modern Art Council, Fund of the
'80s, and Board Designated
Accessions Funds, 90.104.A–D

BARNETT NEWMAN
Zim Zum I

One of only a small handful of sculptural works made by Barnett Newman, *Zim Zum I* (1969) embodies the spiritually inflected themes that resonate throughout his œuvre. Long influenced by Jewish mysticism, Newman forged a complex, religious geometry through a careful attention to proportion and scale. For him the most profound manifestation of this contemplative abstraction was a reductive equation of color, line, and plane, elements he constantly modulated and rearranged in his distinctive "zip" paintings. He pursued a purified language of art, in which the balance of formal elements led to a metaphysical wholeness. Newman viewed his works as loci for meditation, and in them sought to create transcendent places. In *Zim Zum I* line and plane come together in three dimensions, enclosing a literal, sanctified space for the viewer.

The work takes its name from the Hebrew term *tzim tzum,* which means reduction, and the folds of the Cor-ten steel do suggest the potential for compression. The term is used in the Kabbalah—whose mix of logic and magic appealed greatly to Newman—to mean the self-contraction of God in order to make room for creation. The sculpture echoes architectural elements from a synagogue that Newman designed for a 1963 exhibition at the Jewish Museum in New York. His unconventional plan featured a dug-out series of seats surrounding a central place of worship. The synagogue was to be enclosed by walls with accordion folds that would evoke a fluidity of space, both expansive and constricting.

Unlike the more overtly sublime aspirations of works such as *Broken Obelisk* (1963–67), with its precise engineering and assertive thrusting up toward the heavens, *Zim Zum I* exists on a more earthly scale. It lets gravity do its work, balanced solidly on the ground without the use of a base. Created for a sculpture show at the Hakone Museum in Japan, the work was meant to have grander proportions—a height of twelve instead of eight feet—but was scaled back due to shipping constraints. After Newman's death, a second version was manufactured according to these original specifications.

Zim Zum I demonstrates how his sculptures distilled his painterly concerns with surface and shape. Newman often worked with pairs of canvases, developing internal idioms that were refined when set against each other. Here, two steel planes mirror each other, yet are staggered to break their perfect symmetry. The sides of the sculpture form a narrow passage through which the viewer must walk, as if on a ritual journey. While the title has Judaic roots, it is also a verbal play on the zigzagging shape, which jogs through space as if the walls could flex and shrink. *Zim Zum I* was the last of Newman's six sculptural efforts, and its material simplicity recalls the work of Minimalist artists, such as Richard Serra, who were deeply indebted to Newman's formal vocabulary, both painterly and sculptural. —JBW

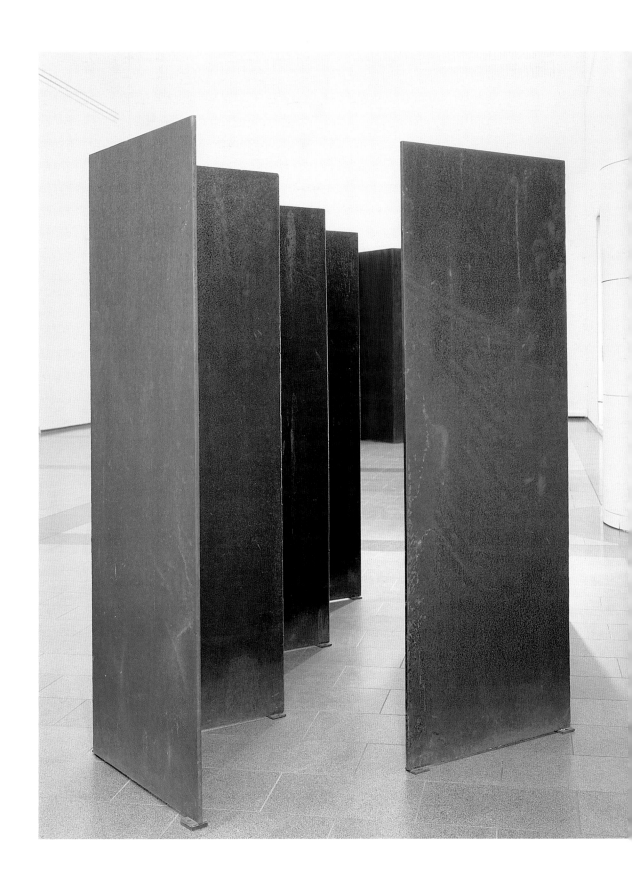

BARNETT NEWMAN
American, 1905–1970

Zim Zum I
1969
Cor-ten steel
96 x 72$\frac{1}{2}$ x 180 in.
(243.8 x 184.2 x 457.2 cm)

Purchased through a gift
of Phyllis Wattis, 98.295.A–B

ROBERT SMITHSON
Nonsite
(Essen Soil and Mirrors)

Although Robert Smithson is best known for monumental Earthworks such as his *Spiral Jetty* (1970) in the Great Salt Lake in Utah, he also introduced landscape elements into the gallery space in a series of smaller sculptures known as *Sites/Nonsites* (1968–69). Smithson's working process for the *Sites/Nonsites* began with excursions to decaying postindustrial zones (mines, quarries, and mineral dumps) in New Jersey and elsewhere. The artist considered these marginalized areas to be in need of urgent attention and reclamation, and he adopted a quasi-scientific approach to recording them through maps, photographs, and sedimentary or rock samples taken from each site. On returning to the studio, Smithson would "frame" the collected fragments of the landscape in aluminum or wood containers of various geometric shapes and orientations, or in arrangements with mirrored surfaces. Such constructions were often accompanied by photodocumentation or other types of renderings of the actual sites. Made at a time when artists were questioning the materials and presentation of art, the *Sites/Nonsites* projects echo Minimalism's emphasis on geometric severity and spare industrial materials, yet they also incorporate the organic disorder of Process and Earth art.

In this particular work from 1969, Smithson, with the assistance of photographers Bernd and Hilla Becher, gathered rocks and earth from a quarry in Essen, Germany, a city known for its coal mining industry. Smithson then divided the soil with a series of vertical mirrors to form a rigorous quadrant. The geometric severity of the slicing mirrors (and of the mirror on which the soil rests) provides an internal and external structure and suggests a kind of crystalline formation. The reflection of the soil in the mirrors creates an illusion of a natural pile of earth that infinitely expands. At the same time that the mirrors reflect the earth, they also reflect the gallery space and viewers approaching the work, thereby blurring boundaries between the original site from which the organic material was derived and its new institutional context. The artwork thus serves to challenge preconceived notions of here and there, presence and absence, someplace and nowhere—a conceptual move already implicit in the term "Site/Nonsite." —CK

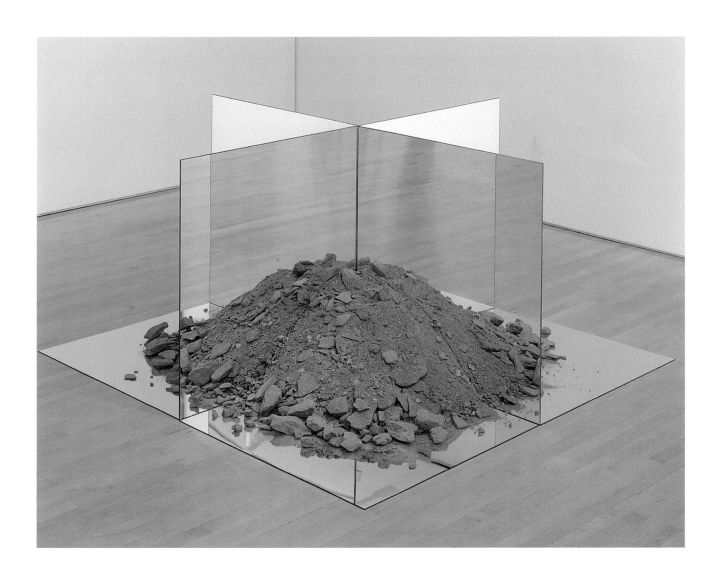

ROBERT SMITHSON
American, born 1938

*Nonsite (Essen Soil
and Mirrors)*
1969
soil and twelve mirrors
36 x 72 x 72 in.
(91.4 x 182.9 x 182.9 cm)

Purchased through a gift of Phyllis
Wattis and the Accessions
Committee Fund, 2000.572.A–P

GORDON MATTA-CLARK
Splitting: Four Corners

Known primarily for site-specific projects called "building cuts," Gordon Matta-Clark developed a dialogue with and against architecture, altering and transforming manmade structures by literally slicing into and dissecting them. Matta-Clark began making his building cuts in 1972 and continued until his early death in 1978. In *Splitting: Four Corners* (1974), the most emblematic of these works, Matta-Clark made use of a condemned, two-story house located in the suburban environs of Englewood, New Jersey. He bisected the house with a chainsaw and removed a portion of the foundation, thereby causing the structure to split open like an enormous clamshell. The artist also extracted the corner portions of the eaves of the building, which are preserved in the sculptural form illustrated at right. The altered house stood in situ from June 1974 until its demolition two months later, and is recorded both in the architectural fragments shown here and in film and photographs of the process.

This act of destruction and reclamation—the literal "deconstruction" of a family abode—represents a radical rethinking of the cultural and philosophical values attached to the American home. Symbolic of the middle-class dream of property ownership and the social ideal of the nuclear family, the suburban residence has often been posited as a source of emotional shelter and physical safety. Matta-Clark's intervention reveals the literal and metaphorical vulnerability of the domestic space, namely, its inability to withstand shifting ideologies and demographic patterns. In a manner akin to an urban archaeologist, he exposes the layers of lath, plaster, wallpaper, and paint that speak to the continuous cycles of human occupation and the inevitable march of time.

Matta-Clark's artistic practice bears striking similarities to that of Robert Smithson, whose work *Nonsite (Essen Soil and Mirrors)* is also featured in this volume. In the course of working toward an architecture degree at Cornell University (1962–68), Matta-Clark encountered Smithson and became deeply influenced by his use of unorthodox materials and intellectual interest in theories of entropy. To some degree, Matta-Clark's building cuts can be considered an urban counterpart to Smithson's Earthworks. Yet they also hark back to the revolutionary readymades of Marcel Duchamp, who pioneered the recontextualization of everyday objects as a means of dissolving the perceived barriers between art and life. As the son of Surrealist painter Roberto Matta Echaurren, Gordon grew up in a household that counted Duchamp among its guests. Matta-Clark's building cuts extend Duchamp's vision into the architectural domain and in doing so challenge our most basic assumptions about the role of the built form in our daily lives. —MG

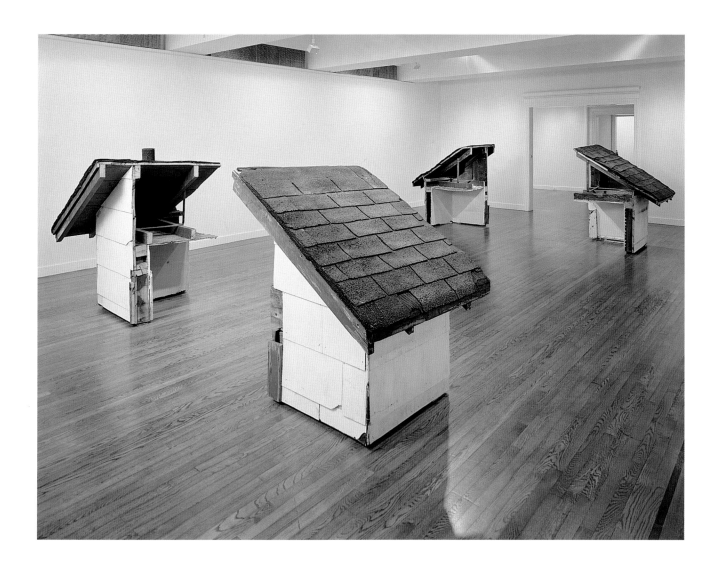

GORDON MATTA-CLARK
American, 1945–1978

Splitting: Four Corners
1974
building fragments
installation dimensions variable; each fragment 54 x 42 x 42 in.
(137.5 x 106.7 x 106.7 cm)

Purchased through a gift of Phyllis Wattis, The Art Supporting Foundation
to the San Francisco Museum of Modern Art, the Accessions Committee
Fund, and the Shirley Ross Sullivan Fund, 2001.0303.A–D

Right now my main activity is social, and what I'm trying to do is make art that's as close to real life as I can without its being real life.[1]

TOM MARIONI
FREE BEER (The Act of Drinking Beer with Friends Is the Highest Form of Art)

Tom Marioni is a seminal figure in the history of Conceptual art in the Bay Area. Born in Cincinnati and trained there in both music and art, Marioni came to San Francisco in 1959. In 1970 the artist founded the Museum of Conceptual Art on San Francisco's Third Street, in the immediate vicinity of the current San Francisco Museum of Modern Art building. In addition to established institutional settings, artists' studios, theaters, and the street itself, Marioni's museum became an important site throughout the 1970s and 1980s for idea-oriented situations created by Marioni and his peers that questioned the notion of art as a collectible commodity.

FREE BEER (1970–79) grew out of a series of events organized around the consumption of beer. These events, in turn, ultimately spawned a number of discrete works of art. The first such event was a performance-based exhibition bearing the name *The Act of Drinking Beer with Friends Is the Highest Form of Art,* held at the Oakland Museum in 1970. After an initial party, its debris (or performance residue) was left in the museum gallery for another ten days. In 1973 the artist purchased a Coldspot refrigerator from a Goodwill thrift store, stenciled the words "FREE BEER" on its door, and opened up his Museum of Conceptual Art for a weekly beer-drinking open house—a ritual that Marioni continues in his studio today. The practice has changed locations over the years, moving in 1976 from the artist's space downstairs to Breen's—a restaurant/saloon—and a few years later to Jerry and Johnny's, the bar next door.

The installation as presently configured is drawn from elements of Marioni's 1979 show at SFMOMA titled *The Museum of Conceptual Art at the San Francisco Museum of Modern Art.* For this show, the artist took over one of the Museum's larger galleries for a monthlong exhibition. His specially lit installation included the original Coldspot refrigerator, which was restocked each day with locally brewed Anchor Steam beer; a table and chairs, where Marioni himself could regularly be found; multiple shelving units to house the empties; and a print that had once been the artist's contribution to the décor at Breen's. These assembled relics from Marioni's performances reflect his pioneering concerns with lived experience and ritual as central to the work of art. By focusing on the very ordinary social activity of beer consumption, the artist subverts class associations with art; by performing these events in gallery settings, he erodes the implicit sanctity of such spaces and challenges the conventional relationship between artist, viewer, and work of art. —JB

1. Marioni, quoted in "Interview by Robin Wright at Crown Point Press, Oakland, California, 1978," *View* 1 (October 1978): [n.p.].

TOM MARIONI
American, born 1937

FREE BEER (The Act of Drinking Beer with Friends
Is the Highest Form of Art)
1970–79
refrigerator, framed print, shelf, beer bottles, and yellow lightbulb
114 x 114 x 60 in. (289.6 x 289.6 x 152.4 cm)

Anonymous gift, 99.70

JESS
Narkissos

San Francisco–artist Jess has been "rescuing or resurrecting images"[1] since the 1950s, carefully incorporating found images into works he calls "translations" and "paste-ups." The former term refers to paintings that closely "copy" extant image sources, with the addition of a literary subtext. The latter relates to the artistic process itself, describing works that are composed of images culled from diverse sources that are then "pasted up" into one visually complicated work. Inspired by a wide range of artists (both visual and literary), drawn from both "high" art sources and "low" popular culture, and informed by Jess's deep interest in mythology and the imagination, these works bring new layers of meaning and new life to old images.

Narkissos (1976–91) is one of Jess's most intricately executed works. It stands as a sort of unfinished masterpiece within the artist's œuvre—"a grand obsession," as he calls it.[2] Indeed, the work, originally conceived as a drawing from which he would then create a translation, occupied Jess on and off for more than thirty years. The painting never came to fruition, however, as the drawing/paste-up took on a life of its own, becoming more and more complex iconographically as Jess attempted to explicate the myth of Narcissus. The result is a somewhat hermetic work of art whose meanings are extremely personal and private (and in this sense a classic Modernist statement), yet one that also breaks the boundaries of fine art by highlighting its own pseudo-Pop aesthetic.

The main source for Jess's interpretation of the myth is the tale as told in Book III of Ovid's *Metamorphoses*. Narcissus was perhaps the most beautiful boy ever born, and throughout his youth was the object of affection of endless suitors, both male and female. Punished by Nemesis for thoughtlessly rejecting the advances of a lovesick boy, Narcissus is cursed to fall in love with his own reflected image. Dying of longing for what is unattainable (the reflection of himself), Narcissus is changed into the narcissus flower by his sisters.

In the drawing, Narcissus, is, of course, the central figure, kneeling down and gazing into the spring. Surrounding him are various figures from the myth, including Eros, who stands atop a rock with bow and arrow just to Narcissus's left, and Ameinias, the spurned lover, who is pictured adjacent to the right elbow of Narcissus. Most of the individual images are cutouts of engravings by other artists who have treated this theme. However, unexpected images intrude into the mythological landscape. Narcissus holds in his right hand a group of panels from a *Krazy Kat* comic strip, and behind Ameinias is a still of a mob scene borrowed from Fritz Lang's *Metropolis*. An image of the famous Monadnock building in Chicago stands in for one of the rugged cliffs. Such devices "offer oblique rhymes, visual puns, displacements and substitutions" that, when juxtaposed with imagery from the myth itself, offer a fascinating and delightful visual experience.[3] —MH

1. Jess, quoted in "An Interview with Jess," Michael Auping, *Jess: A Grand Collage, 1951–1993* (Buffalo, N.Y.: Albright-Knox Art Gallery), p. 25.
2. Ibid., p. 27.
3. Michael Palmer, "On Jess's *Narkissos,*" in Auping, *Jess: A Grand Collage*, p. 95.

JESS
American, born 1923

Narkissos
1976–91
pencil on paper and paste-up
70 x 60 in. (177.8 x 152.4 cm)

Purchased through the gifts of Mrs. Paul L. Wattis, Elaine McKeon, Judy and John Webb, Bobbie and Michael Wilsey, Jean and Jim Douglas, Susan and Robert Green, Pat and Bill Wilson, and the Accessions Committee Fund: gift of Frances and John Bowes, Shawn and Brook Byers, Emily L. Carroll and Thomas W. Weisel, Doris and Donald G. Fisher, Diane and Scott Heldfond, Maria Monet Markowitz and Jerome Markowitz, and the Modern Art Council, 96.492

When Philip Guston turned from abstract to representational works in the late 1960s, many in the art world were stunned. Although he was an accomplished New York School artist, he began using figuration to explore political and personal subjects. His 1970 exhibition at the Marlborough Gallery in New York signaled a revised art practice that broke with the formalism of abstraction and moved into satirical depictions of the social and individual realms. Using a highly charged vocabulary of forms, he confronted head-on the messy stuff of the world: piles of shoes, clocks, truncated limbs, and hooded Klansmen.

PHILIP GUSTON
Red Sea; The Swell; Blue Light

Red Sea; The Swell; Blue Light (1975) shows Guston at his most monumental. Together, the canvases tell a story in three parts dealing with a theme of great importance to him in the mid-1970s: the deluge. Many of Guston's late drawings and paintings reveal the influence of cartoons, and here he merges the classical triptych with the multipaneled format of comic strips. The allegorical narrative is reminiscent of Old Testament flooding, and the title clearly draws inspiration from the Biblical narrative of Moses parting the Red Sea. The miraculous taming of the sea gave the Jews a safe passage, after which the waves engulfed their Egyptian enslavers.

In *Red Sea,* crimson waters roil and toss up a tangle of feet and legs. The bloody, cresting sea becomes a downpour of paint as an army of body parts is overwhelmed by the tide. In *The Swell,* the dry land is thinner yet, becoming only a narrow ledge at the bottom. As the waters rise, a disembodied eye gazes up for redemption. (Guston's painted

PHILIP GUSTON
American, born Canada,
1913–1980

Red Sea; The Swell; Blue Light
1975
oil on canvas
73 x 237 ¹/₂ in. (185.4 x 603.3 cm)

Purchased through the Helen Crocker
Russell and William H. and Ethel W.
Crocker Family Funds, the Mrs. Ferdinand
C. Smith Fund, and the Paul L. Wattis
Special Fund, 78.67.A–C

persona emerged in the early 1970s as a head eclipsed by its single, staring eye.) An open book floats on the torrents, and a window-shade string dangles down as if it could provide escape. Finally, *Blue Light* presents some return to stability. The head rights itself and emerges from the flood as legs bob to the surface. Rain continues to fall, but a sun is scratched into the surface of the black sky. Out of the dark appears a small patch of blue. Wood beams, possibly canvas stretchers, appear to offer some shelter at the shore.

Although the triptych carries the viewer along with the sweep of its scriptural storytelling, the canvases display the qualities of paint and light that defined Guston's previous abstract work. The palette of pink, red, gray, and blue is pure Guston. But here paint becomes a vehicle for symbolic weight, as obdurate things, with all their history, intrude upon simple planes of color. For Guston, the practice of figurative art-making was an exercise in ethics, and he used his painterly eye to bear witness to such issues as racial injustice. As he wrote in 1973: "Our whole lives . . . are made up of the most extreme cruelties of holocausts. We are witnesses of the hell. . . . To paint, to write, to teach in the most dedicated sincere way is the most intimate affirmation of creative life we possess in these despairing years."[1] In this work, the journey from darkness to light displays Guston's continued faith in the redemptive power of art. —JBW

1. Guston, quoted in Dore Ashton, *A Critical Study of Philip Guston* (New York: Viking Press, 1976; reprint, Berkeley: University of California Press, 1990), p. 177.

ROBERT ARNESON
American, 1930–1992

California Artist
1982
stoneware with glazes
68 ¼ x 27 ½ x 20 ¼ in.
(173.4 x 69.9 x 51.4 cm)

Gift of the Modern Art Council,
83.108.A–B

ROBERT COLESCOTT
American, born 1925

End of the Trail
1976
acrylic on canvas
74 3/4 x 96 1/4 in. (189.9 x 244.5 cm)

Purchased with the aid of funds from the
National Endowment for the Arts, 1975
Soap Box Derby, and the New Future
Fund Drive, 77.78

ANSELM KIEFER
German, born 1945

Osiris und Isis (Osiris and Isis)
1985–87
oil, acrylic, emulsion, clay, porcelain,
lead, copper wire, and circuit board
on canvas
150 x 220 ½ x 6 ½ in.
(381 x 560 x 16.5 cm)

Purchased through a gift of Jean Stein
by exchange, the Mrs. Paul L. Wattis Fund,
and the Doris and Donald Fisher Fund,
87.34.A–C

SIGMAR POLKE
German, born 1941

*The Spirits That Lend Strength
Are Invisible III (Nickel/Neusilber)*
1988
nickel and artificial resin on canvas
157 ¹/₂ x 118 ¹/₈ in. (400 x 300 cm)

Gift of the friends of John Garland Bowes,
William Edwards, and Donald G. Fisher,
and the Accessions Committee Fund: gift
of Frances and John G. Bowes, Shirley
and Thomas Davis, Mr. and Mrs. Donald G.
Fisher, and Mimi and Peter Haas, 89.2

GERHARD RICHTER
Lesende (Reader)

In a gambit to address the dilemma of what to paint, in 1962 the German artist Gerhard Richter painted a canvas directly from a photograph. This decision marked the beginning of an artistic career that has foregone associations with established art movements and styles in order to pursue an intense engagement with the act of painting and its history. In the 1960s Richter argued that painting from banal photographs freed him from variables such as composition, subject matter, and content, with which painters throughout history have had to contend. This strategy also enabled him to confront the very invention that had usurped painting's traditional function of capturing reality. Although by the 1970s Richter had moved from the photo paintings to a series of all-gray paintings, color charts, mirror paintings, and colorful abstractions, he is perhaps best known for his photo paintings and the rhetoric surrounding them. Occasionally he has returned to this body of work, and his ability to move effortlessly from abstraction to figuration has made the project of assigning Richter one stylistic label a pointless task.

Lesende (1994), a painting of a snapshot Richter took of his wife, Sabine Moritz, depicts her reading in profile, head bent, eyes lowered, and hair pulled back, the luminosity and softness of her skin captured in paint. Interestingly, it was completed after Richter conceded that he had in fact chosen his source photographs for their content: "I may have denied this at one time, by saying that it had nothing to do with content, because it was supposed to be all about copying a photograph and giving a demonstration of indifference."[1] Richter has also admitted that composition plays a role in his choice of a specific photograph: "I see countless landscapes, photograph barely 1 in 100,000 and paint barely 1 in 100 of those that I photograph. I am therefore seeking something quite specific; from this I conclude that I know what I want."[2] *Lesende* is notable for illustrating Richter's honesty about how he approached the photo paintings, an honesty that reveals an interest in content, a search for meaning, and a closeness to the subject quite different from the distance he sought in the early photo paintings.
—TM

1. Richter, "Interview with Benjamin H.D. Buchloh, 1986," in Hans-Ulrich Obrist, ed., *Gerhard Richter: The Daily Practice of Painting; Writings and Interviews, 1962–1993* (Cambridge, Mass.: MIT Press; London: Anthony d'Offay Gallery, 1995), p. 143.
2. Richter, "Notes, 1986," in Obrist, *The Daily Practice of Painting,* p. 130.

GERHARD RICHTER
German, born 1932

Lesende (Reader)
1994
oil on linen
28 1/2 x 40 1/8 in. (72.4 x 101.9 cm)

Purchased through the gifts of Mimi and
Peter Haas and Helen and Charles
Schwab, and the Accessions Committee
Fund: Barbara and Gerson Bakar,
Collectors Forum, Evelyn D. Haas, Elaine
McKeon, Byron R. Meyer, the Modern Art
Council, Christine and Michael Murray,
Nancy and Steven Oliver, Leanne B.
Roberts, Madeleine H. Russell, Danielle
and Brooks Walker, Jr., Phyllis Wattis,
and Pat and Bill Wilson, 97.36

Since the late 1970s, when he began showing inflatable plastic toys in art galleries, Jeff Koons has been relentlessly provocative in his artistic endeavors. Working within the legacy of Marcel Duchamp, who in 1917 titled an ordinary urinal *Fountain* and submitted it to an art exhibition, Koons has been recontextualizing and re-creating everyday objects and images that reflect various aspects of public consumerism—the consumption of everything from road-stop souvenirs and vacuum cleaners to cartoons, hard liquor, sex, and art.

JEFF KOONS
Michael Jackson and Bubbles

For *Michael Jackson and Bubbles* (1988), from the artist's *Banality* series, Koons directed Italian master-ceramicists to create a greatly oversized figurine from a publicity photograph of the celebrity and his chimpanzee. The performer and his pet are posed as companions, wearing matching gold band uniforms and an excess of makeup that stands in for genuine facial expression. Bubbles is nestled in Jackson's lap, their limbs confused to the point where one of the legs of the chimp could easily be mistaken for a third arm of the singer. They are instantly recognizable and undeniably beautiful.

Yet in the cold, shiny surface of their faces can be found rather disturbing issues of race, gender, sexuality, and the pursuit of beauty that are often part and parcel of our fascination with public personas. Over the course of rising from child stardom in the early 1970s, as the youngest member of the Jackson Five, to an unsurpassed level of international fame from the 1980s to the present, this cultural icon has undergone countless physical transformations. Koons shows Jackson at a moment when this star, whom we know to be a black man, more closely resembled a white woman, and before the facial disfigurement Jackson has subsequently suffered. The three-dimensional sculpture inhabits our space, but Michael Jackson himself is a man whom we can never know. No matter how much media attention he receives, to the millions of people in whose consciousness he resides he will never be more than the flat character of tabloid reproductions and television. The artist's use of ceramics for this work points to the hollowness and fragility of celebrity status, which Koons is well positioned to consider given his far-reaching art-world fame. —JB

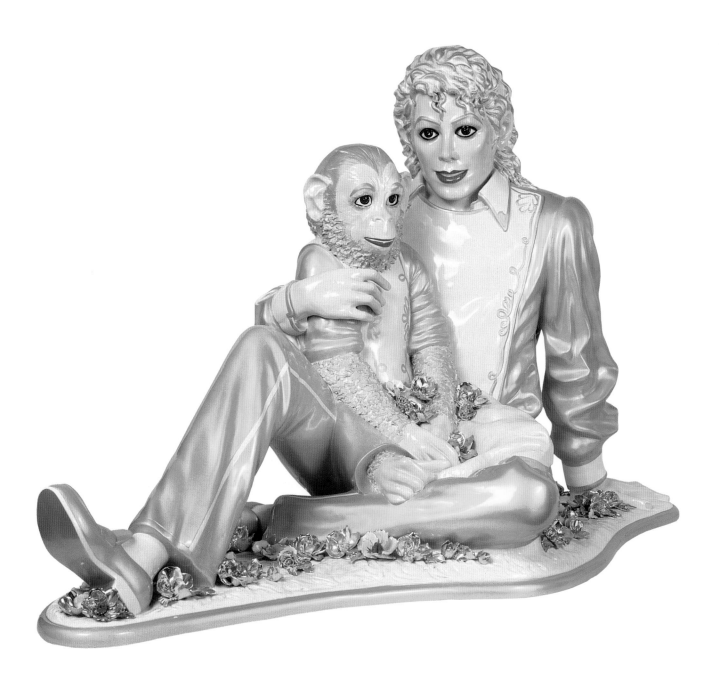

JEFF KOONS
American, born 1955

Michael Jackson and Bubbles
1988
porcelain, ed. 2/3
42 x 70 ¹/₂ x 32 ¹/₂ in.
(106.7 x 179 x 82.6 cm)

Purchased through the Marian and
Bernard Messenger Fund and restricted
funds, 91.1

KATHARINA FRITSCH
German, born 1956

Kind mit Pudeln
(Baby with Poodles)
1995–96
plaster of Paris, foil, polyurethane,
and paint
15 ³/₄ x 201 ¹/₂ x 201 ¹/₂ in.
(40 x 511.8 x 511.8 cm)

Accessions Committee Fund: gift of
Collectors Forum, Jean and Jim Douglas,
Mimi and Peter Haas, Susan and Robert
Green, Pam and Dick Kramlich, Vicki and
Kent Logan, Helen and Charles Schwab,
Norah and Norman Stone, and Judy and
John Webb, 96.490.A–RRRRRRRRR

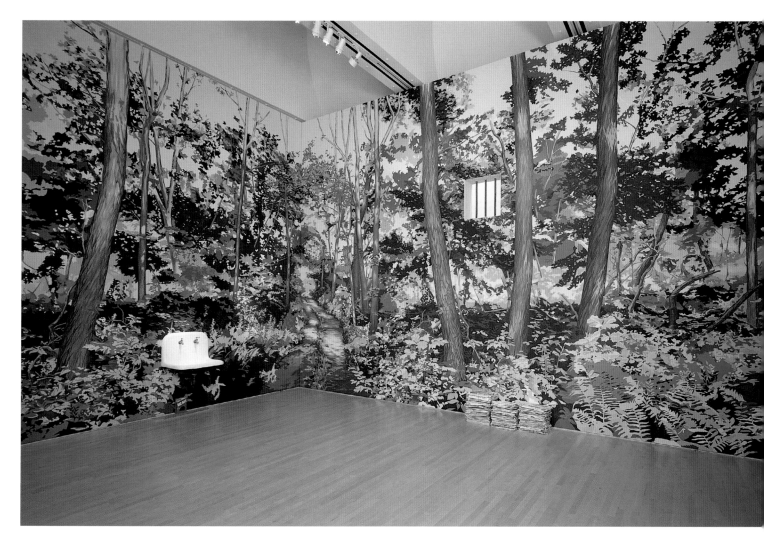

ROBERT GOBER
American, born 1954

Untitled installation including:

Rat Bait
1992
cast plaster with casein and silkscreen ink, ed. 4/10
9 1/8 x 6 1/8 x 2 in. (23.2 x 15.6 x 5 cm)

Untitled
1992
stainless steel, painted bronze, and water, ed. 4/8
32 x 30 x 20 in. (81.3 x 76.2 x 50.8 cm)

Prison Window
1992
plywood, forged iron, plaster, latex paint, and lights, ed. 4/5
48 x 53 x 36 in. (121.9 x 134.6 x 91.5 cm)

Accessions Committee Fund: gift of Frances and John Bowes, Collectors Forum, Jean and James E. Douglas, Jr., Susan and Robert Green, Mimi and Peter Haas, Judy C. Webb, and Thomas W. Weisel and Emily Carroll, 92.401–403

Newspaper
1992
photolithography on Mohawk Superfine paper, ed. 7/10
dimensions variable

Ruth and Moses Lasky Fund purchase, 92.400

Living amidst war, my role is to think of war, both from the point of view of the victim and of the perpetrator. I am interested in war as a part of human history, as a central activity of all societies in the past as well as in the present. The enemies change, the forms of annihilation change, the weapons change, but the nature of war is the same.[1]

DORIS SALCEDO
Unland
irreversible witness

Sculptor Doris Salcedo's distinguished body of work addresses the condition of almost unimaginably widespread violence in her homeland of Colombia. Using a post-Minimal vocabulary of geometric forms and everyday materials, Salcedo evokes the massive human toll of ongoing drug and civil wars, and the ways in which the lives of survivors are forever defined by the losses they have suffered. Extraordinarily beautiful and still, these works function both as memorials to the dead and as evocations of survivors' feelings of inescapable emptiness. "My work deals with the fact that the beloved—the object of violence—always leaves his or her trace imprinted on us," Salcedo has remarked. "Simultaneously, the art works to continue the life of the bereaved, a life disfigured by the other's death."

Unland: irreversible witness (1995–98) is one of three related sculptures taking the form of tables—typical gathering places that here sit eerily unpopulated and silent. All three works bear titles beginning with *Unland*, an invented word suggesting dislocation and placelessness, a land that no longer is what it was. Along with the two other sculptures—*Unland: the orphan's tunic* and *Unland: audible in the mouth*—*Unland: irreversible witness* has a subtitle borrowed from a poem by Paul Celan, the Romanian-born Holocaust survivor whose stark artistic style and life experiences parallel those of Salcedo. Having interviewed many individuals in Colombia who have lost loved ones and continue to live under conditions of fear, the artist considers herself a secondary witness to their suffering.

This work consists of two tables that appear to have been spliced or grafted together. Upon this form rests a doll bed—an abandoned toy, tipped on its side, that prompts one to consider the physical disarray that results from violent acts, as well as the tender age of some of the victims. The entire surface, including the metal bed, is covered with a thin skin of fabric—a protective layer that has been sewn to the table by threading hair through thousands of holes drilled into the wood. Salcedo's process is excruciatingly labor-intensive, and she purposefully exhibits these works under an even wash of low, eerie light, creating conditions for, in her words, "the silent contemplation of each viewer [that] permits the life seen in the work to reappear." As one looks at these pieces, "change takes place, as if the experience of the victim were reaching out, beyond, as if making a bridge over the space between one person and another. To make this connection possible is the important thing." —JB

1. All quotations of the artist are taken from Charles Merewether's interview with Doris Salcedo in the unpaginated brochure "Unland: Doris Salcedo, New Work," San Francisco Museum of Modern Art, 1999.

DORIS SALCEDO
Colombian, born 1958

Unland
irreversible witness
1995–98
wood, cloth, metal, and hair
44 x 98 x 35 in.
(111.8 x 248.9 x 88.9 cm)

Purchased through the Jacques and
Natasha Gelman Fund and the Accessions
Committee Fund, 98.530

RICHARD TUTTLE
American, born 1941

Ten, A
2000
mixed media
ten parts; each 10 x 10 in.
(25.4 x 25.4 cm)

Accessions Committee Fund purchase,
2001.168.A–J

FELIX GONZALEZ-TORRES
American, born Cuba, 1957–1995

Untitled
1992/1993
offset print on paper (endless copies)
ideal height 8 in. (20.3 cm);
each sheet 33 ¹/₂ x 44 ¹/₂ in. (85.1 x 113 cm)

Accessions Committee Fund: gift of Ann S. Bowers,
Frances and John Bowes, Collectors Forum, Elaine
McKeon, Byron R. Meyer, and Norah and Norman
Stone, 94.431.A–B

KERRY JAMES MARSHALL
American, born 1955

Souvenir III
1998
acrylic with glitter on unstretched
canvas banner
108 x 156 in. (274.3 x 396.2 cm)

Accessions Committee Fund: gift of
Shawn and Brook Byers, Collectors
Forum, Emily Carroll and Thomas Weisel,
Doris and Donald G. Fisher, Susan and
Robert Green, Diane and Scott Heldfond,
Patricia and Raoul Kennedy, Elaine
McKeon, Elle Stephens, and Phyllis
Wattis, 99.213

CHRIS OFILI
British, born 1968

Princess of the Posse
1999
acrylic, collage, glitter, resin, map
pins, and elephant dung on canvas
96 x 72 in. (243.8 x 182.9 cm)

John Caldwell, Curator of Painting and
Sculpture, 1989–93, Fund for
Contemporary Art purchase,
2000.40.A–C

KARA WALKER
American, born 1969

No Mere Words Can Adequately
Reflect the Remorse This
Negress Feels . . . (detail)
1999
cut paper and adhesive
overall size of installation
approximately 11 x 65 ft.
(3.4 x 19.8 m)

Purchased through a gift of Shawn
and Brook Byers, 2000.306

JIM HODGES
American, born 1957

No Betweens
1996
silk, cotton, polyester, and thread
360 x 324 in. (914.4 x 832 cm)

Purchased through a gift of Kimberly
S. L. Knight and John B. Knight III,
97.514

SARAH SZE
American, born 1969

Things Fall Apart (detail)
2001
mixed-media installation with vehicle
variable dimensions

Accessions Committee Fund purchase,
2001.0067.A–E